THE POETIC
Landscape

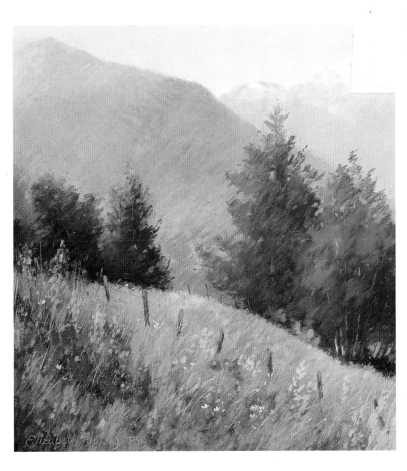

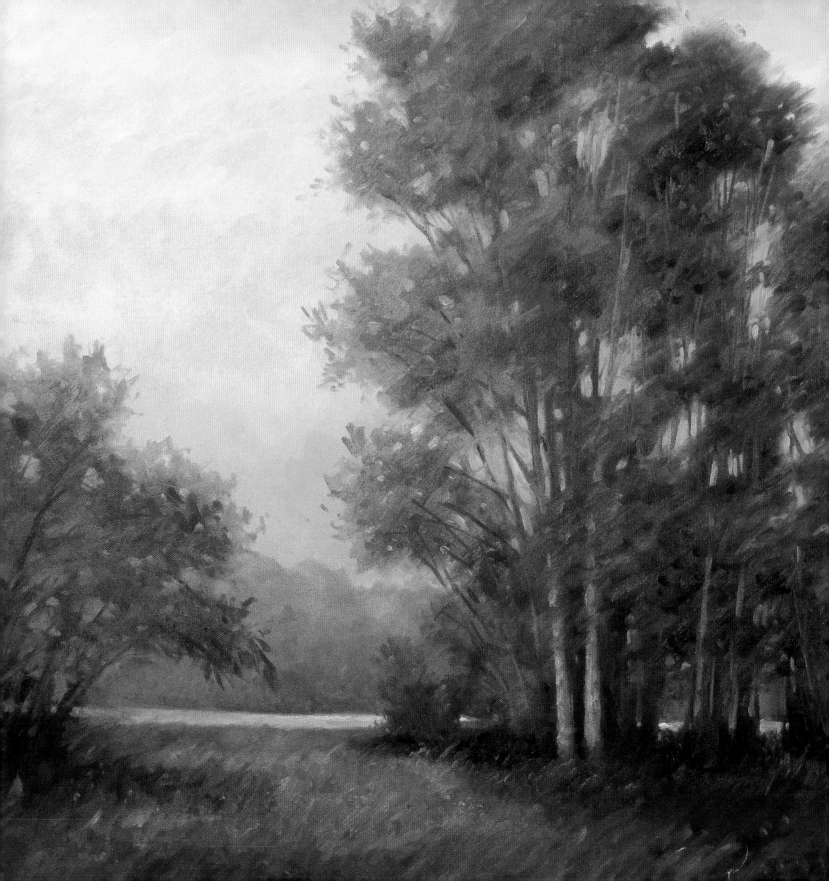

THE POETIC
Landscape

A CONTEMPORARY VISUAL AND PSYCHOLOGICAL EXPLORATION

ELIZABETH MOWRY

WATSON-GUPTILL PUBLICATIONS/NEW YORK

FOR JENNIFER, ALBERT, AND ANDREW
WITH LOVE

To the Spirit that awakened me to nature's poetry; to an introspective childhood that nurtured a gift of uncommon sensitivity through the insecurities of adolescence to a mature tranquility; to my dear friends who have encouraged me along my own path, most frequently with faith, sometimes with apprehension, and always with love; to the celebration of spontaneity, the joy of quiet acceptance, and the serenity of letting go with composure; and finally to all those who graciously or unknowingly provided the opportunities for me to learn the lessons that were mine to learn, I thank you.

It is with immense pleasure that I express my appreciation to the talented professional staff at Watson-Guptill Publications for transforming an artist's unrelenting obsession and four years of writing and painting into what appears here between the covers of The Poetic Landscape: *Candace Raney, acquisitions editor, for her enthusiasm and guidance; my editor, Mary Beth Brewer, who worked so diligently to preserve my vision for this book; designer Areta Buk, who converted a pile of images into something greater than the reality; Ellen Greene, for taking time to provide a view of elegant possibilities; Sharon Kaplan, for her generosity; and Alicia Kubes, for weaving together the multitude of details that are ultimately necessary for the fabric of any undertaking to hold together on its own. Even before that, I thank Jim Markle, who backed up his belief in the idea for this book with a gift of time away from his own easel, my deepest gratitude.*

First published in New York in 2001 by Watson-Guptill Publications,
a division of BPI Communications, Inc., 770 Broadway, New York, N.Y. 10003

Library of Congress Cataloging-in-Publication Data

Mowry, Elizabeth.
The poetic landscape : [a contemporary visual and
psychological exploration] / Elizabeth Mowry
p. cm.
Includes index.
ISBN 0-8230-4067-4
1. Landscape painting. I. Title.

ND1342.M69 2000
758'.1–dc21
00-043306

Printed in China

1 2 3 4 5 6 7 8 9 / 09 08 07 06 05 04 03 02 01

Contents

Introduction

"In one sense the great poet, and the great naturalist, are the same . . . things take definite and distinct shape to them; they are capable of vivid impressions."

JOHN BURROUGHS

What many artists and poets have in common is an excruciating sensitivity to their surroundings. Nature takes a deep hold on them when they observe it quietly, and the intensity of the relationship that sometimes develops between the artist and the land has much to do with the vision that inspires the painted image.

Poetic landscape has to do with mood, ideas, and design, all more ethereal than realistic. It moves beyond the craft of painting into a tenuous space where intellect and spirit direct technique. The poetic landscape gently reminds us of the importance of tranquility. Since it declares the beauty or tragedy of a singular idea, the artist may have to edit reality severely. Also a poetic landscape always falls just short of closure in that it presents a sense of place that evokes the viewer's memories or yearnings based on past experiences. The artist visually describes the scene, but the viewer completes it by supplying what is personally meaningful. Ideally, through artful composition and the wealth of what lies within, it becomes possible for the artist to choreograph an idea on canvas in a way that guides the viewer into a landscape to a place of quietude and rest.

Poetry has been described as the expression of universal truth. Nature, too, is universal because it can be understood by everyone. Poetic landscape embraces the natural elements familiar to all people, dismissing the rare and the specific. The artist extracts the poetry that lies in nature by integrating selected ordinary elements in a way that can result in an extraordinary painting.

Much of poetic landscape is introspective. Its strength emerges from what is left unexpressed, making space for the silenced past to speak. Ultimately, a poetic landscape transports the viewer beyond an awareness of the painted scene to a powerful sense of the place itself.

This book is not a step-by-step manual on "how" to paint the poetic image. Instead I hope that it will encourage the reader to ask, and then thoughtfully answer, the question "why?" A good landscape painting represents a delicate balance between both the strength and the fragility that are rooted in nature. A good life requires balance as well. The purpose of this book is not to postulate a formula for creating the poetic landscape, but simply to examine some of the qualities that consistently occur in works regarded as poetic. My hope is that this will help us understand the place they assume in our lives as well.

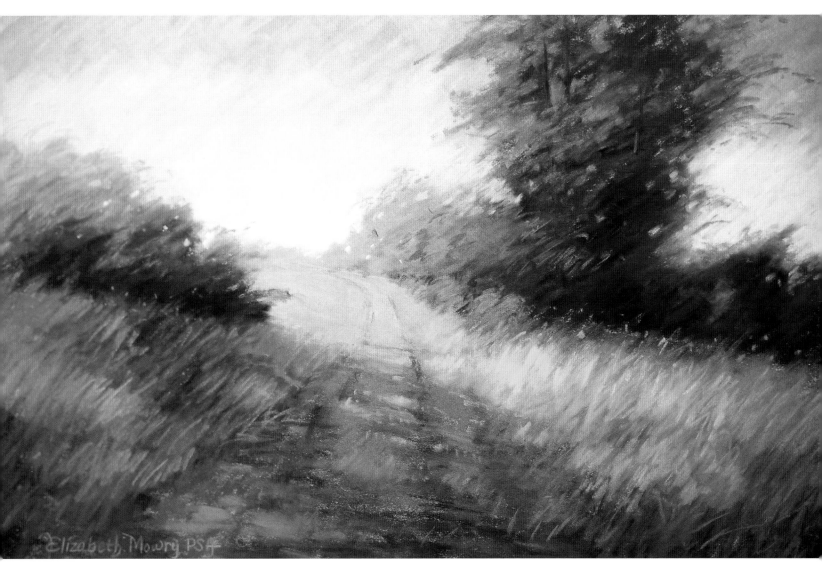

VIRGINIA PATH
14 × 20 inches, pastel, 1996

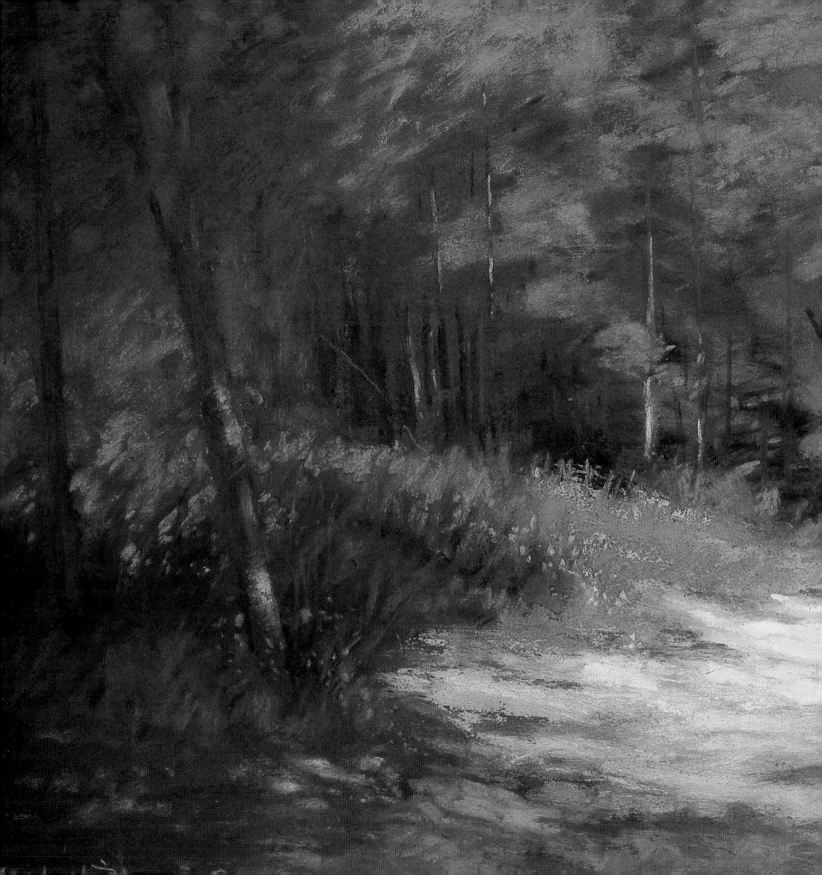

Nature as the Subject

"You cannot find what

the poets find in the woods

until you take the poet's heart

to the woods."

JOHN BURROUGHS, *HARVEST OF A QUIET EYE*

"The truth is in nature, and I shall prove it." Frustration echoed in those words muttered by an old and angry Cézanne, whose gospel was fidelity to nature and who regarded theory with disdain. In contrast, Monet said that his idea of painting the landscape was to paint his own naive impression of the scene before him. The most serious painters created their own agendas, fired by personal passions. But when all is said, Emile Zola's observations in *The Masterpiece* that "truth and nature are the . . . essential controlling factors in art" and "without them everything verges on madness" take on new meaning within the complexity of our lives today.

All landscape artists, sooner or later, develop their own views about how to paint nature. Sunburned plein air artists weather the elements and lug easels and painting materials over terrain that animals instinctively avoid. Tourists feel connected to these picturesque figures in the fields who have chosen to paint the same places they have selected to explore. They represent an ideal life. Other landscape artists work indoors, composing paintings from sketches and studies or photographs. Only close friends know that these monastic, seldom-seen studio artists have bizarre rituals of procrastination and often don't answer their telephones. Neighbors are intrigued by the aura of quiet mystery that builds around them. Ultimately differences in painting approach seem to have little effect on the quality of work. Artists frequently shift their painting habits between the two extremes before they find a comfortable balance.

It is interesting that the rise of landscape painting in the nineteenth century in France came about at the same time as the Industrial Revolution, which was a giant step forward, but brought with it a dark side. Then, as now, nature symbolized stability. Suddenly the permanence of all that was rural began to yield to the unknown. As changes rapidly transformed the continent, painters were among the first to protest the sprawling growth of factories and railways. "Everything I wanted to paint has been destroyed," lamented Charles Daubigny in 1854. Those who were insensitive to the landscape innocently, but sometimes knowingly, exploited the natural bounty of the land. Today their descendants see firsthand that the earth is seriously threatened.

We now realize that we must take responsibility for the preservation, conservation, and replenishment of what we are destroying because after our basic needs are met it is our response to aesthetic experiences that continually refines, adjusts, and expands our ideas to promote growth and maturity. Ultimately it enhances our lives. It is important to remember that art is a part of our life, not separate from it, and that the ancient values of integrity, beauty, and poetry, which give meaning to our lives, are inspired by nature. Our role must be that of custodians, not owners, of the earth and its creatures. Today there is a renewed and reverent interest in the landscape. After years of using we are faced with the unequivocal reality that what we have taken for granted can end. To the higher-thinking inhabitants of the earth, the landscape has become sacred. They desperately want to educate others toward the same attunement. The endangered always becomes precious; the rare commands a higher value. Nature is pursued as the wellspring of peace and tranquility because the lives we carve out for ourselves today

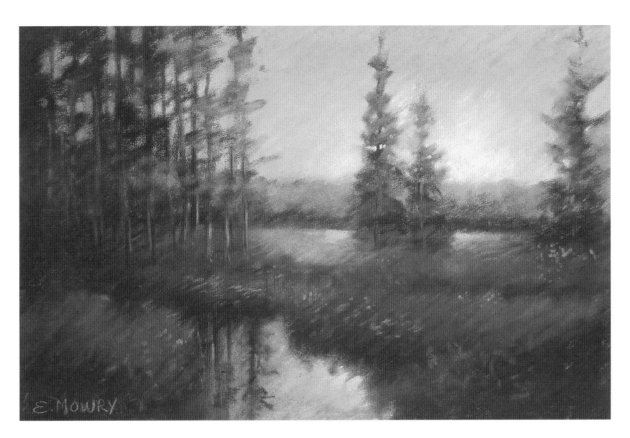

LAST LIGHT I, II, III
8 × 12 inches, pastel, 1998

The stillness inherent in this Oregon scene remains constant even when the subject is
painted at different times. As our diminishing landscape becomes sacred, nature is pursued
as a wellspring of tranquility, and the poetically painted landscape can help us find it.

are beginning to border so closely on the edge of the madness that Emile Zola wrote about.

The universality of nature transcends all time and cultures. Poetry does this as well, but to experience the beauty and poignancy of a poem, we need to read it or listen to it. A landscape painting needs only to be seen. It requires no translation because it conveys meaning that transcends language. Differences in nationality, sex, age, health, education, and financial status present no barriers to the stillness experienced by visitors from all over the world who stand beside one another in the Orangerie in Paris to view three hundred and sixty degrees of Monet's water lilies. The hush in the room is not required; it just happens. As author Hal Borland reminds us, "The land persists and something in the human heart responds."

John Burroughs was fond of reminding us that the messages of nature lie close at hand and that an artist's paintings should come from contact with the land based on personal observations. Nature, although threatened, is. And although we may have to travel a little farther for views that offer us the harmony we may lack in other areas of our lives, our response to nature is still ignited by the wildflowers, the path that winds down into the valley, the pounding of the sea upon the rocks, the brilliant gold of shimmering aspens, the float of a cloud, or a gentle rainfall. Just as we must find humor in our own lives, smile our own smiles, and rise up after defeat on our own because no one else can suffer for us, we can only experience the fundamental calm of nature's offerings by being open to the gift ourselves.

Although an intelligent sorting out and putting together of nature's landscape components is

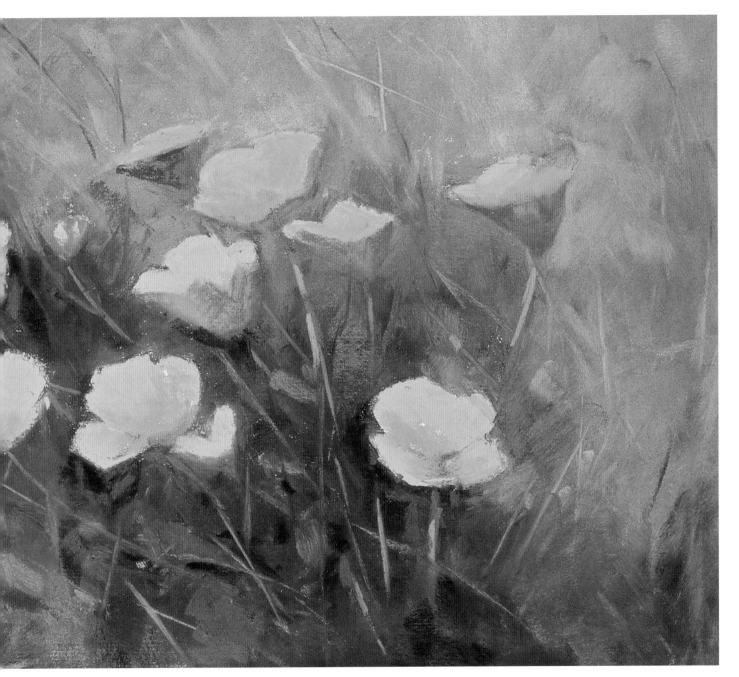

CALIFORNIA POPPIES
7 × 12 inches, pastel, 1999

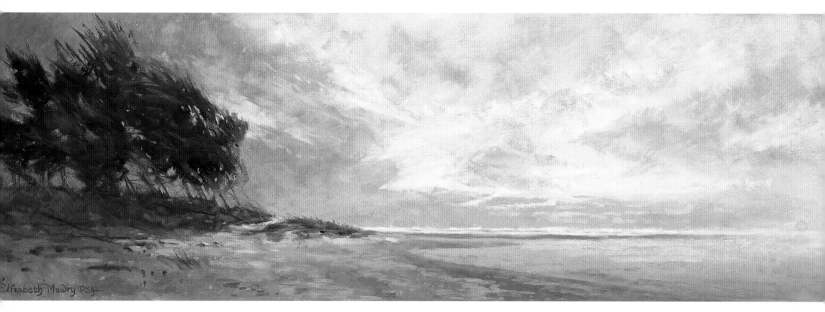

OREGON COAST I

10 × 30 inches, pastel, 1999

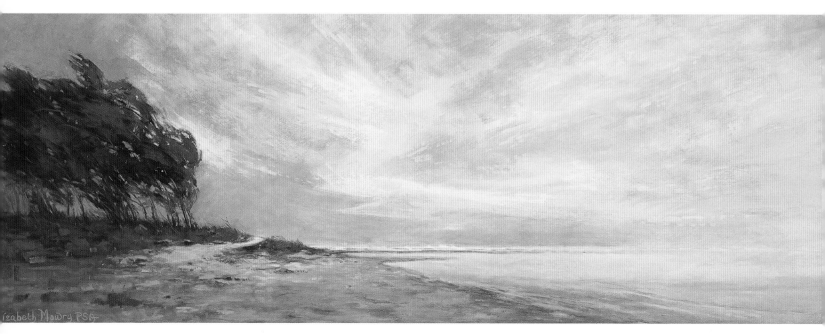

OREGON COAST II

13 × 34 inches, pastel, 1999

important to all landscape painting, the poetic land-scape cannot evolve from bits and pieces that lack a point of reference. When the relationship between an individual and the land is intense, the magic of that attunement has much to do with the formation of artistic vision. One has to be out in nature enough to recognize the poetry and then throw one's entire soul into painting it. Although the artist makes adjustments throughout the painting process, the initial idea always comes from something in our experience that we have seen or felt.

The intensity of an artist's relationship with nature will frequently lead to a deeper exploration of the subject. *Oregon Coast I, II,* and *III* are based on attentive observations of light and color over a relatively short time on the same day. Differences between the first and second paintings have much to do with the tonal effects of the changing sky color. In the third paint-ing, the lower color key and the diminishing light tell the viewer that even more time has elapsed.

As we grow wiser from our life experiences, we also become aware of our mortality. Time is our most precious commodity, yet society keeps enticing us with more and more popular ways to spend it. Does the following sound familiar? "Just five minutes a day for this . . . three minutes a day for that . . . one more class per week to know this . . . and a set of only ten tapes to learn that . . . only one meeting per month for this," and so on. No wonder you missed the snow-drops, and the butterflies, and the sweet smell of ripened pears, and the last white rose of summer.

Sometimes I find myself at a museum standing silently before a landscape in awe of the painting's depth and the power. On other occasions, from across a room my eyes seek out a painted scene that pulls me emotionally beyond the painting to the place itself. Over the past fifty years, the movement back to nature has gathered momentum, and the correlation between nature and quality of life stands affirmed. The interconnectedness of all things has been substantiated and a kinship with nature is con-stantly growing stronger. Natural areas become more precious as the danger of irrevocable loss draws nearer, making landscape painting more important today for everyone, including the artist.

We absorb best what we enjoy most. It is also true that we absorb the secrets of the landscape by being in it. Nature takes a deep hold on us when we become still. It is within that stillness that we learn to read nature like a book—the scale, the transition from one type of area to the next, the sculptural qualities, the diversity, the texture, and the color. No one can hand us this knowledge. It is from our experiences that we add to our repertoire, gathering visual images that blend together in our own collective mind and spirit. It is from here that the mind sorts out what is useful; the spirit lets us know what is meaningful, and then the hand follows. The more we absorb, the more selective we become. We innately seek out harmonious order from complexity, but first we must collect enough information to make artistic comparisons and sound decisions. It is through the senses that we have aesthetic experiences and then make judgments about what we see and hear, and even taste, smell, and feel. All of this harvesting is quietly exciting because every day we are evolving.

Can our choice to paint the landscape be regarded as stagnant? For the inquisitive mind, it cannot. The

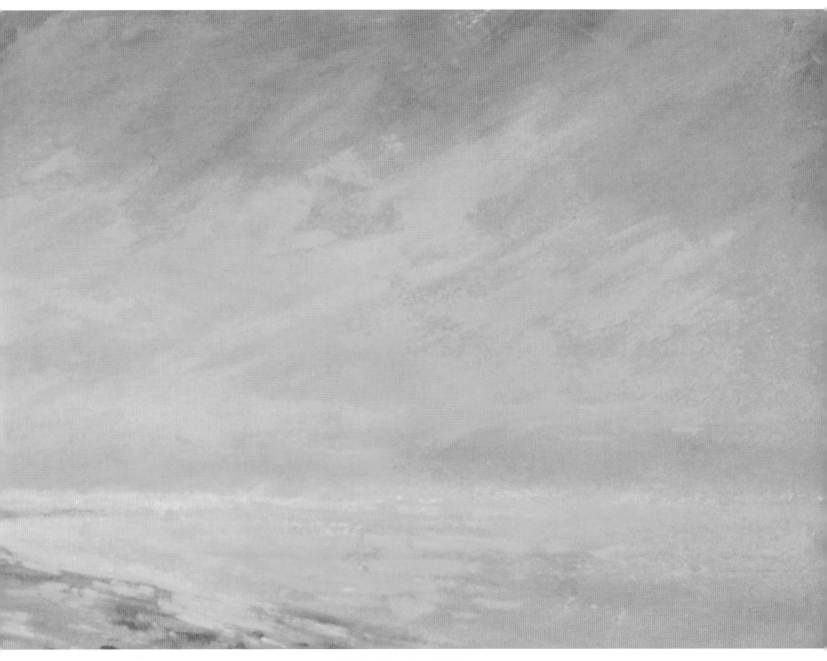

OREGON COAST III

5 × 14 inches, pastel, 1999

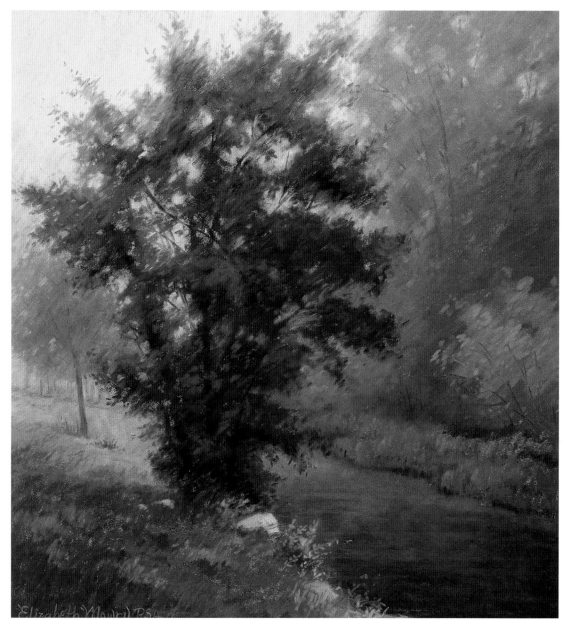

ALONG THE EPTE III
14 × 13 inches, pastel, 1996

Although nature provides us with enormous diversity, the focal point in a landscape painting can be as simple as a single tree. In the magical morning light of Normandy, the placement, size, and color of this graceful tree assumes importance in relation to the other parts of the painting.

landscape artist who takes the time to develop an enhanced perception of the natural world will always have the power to translate beauty and speak to the yearnings of others. A poetic landscape frequently has the capacity to be stark in execution but stunningly complex in effect. This is particularly obvious, for instance, when a simply painted landscape conveys happiness and longing at the same time.

Nature is the sum of its components and their relation to one another. The diversity of mountains, forests, plains, marshes, and water offers an abundance of material to be used in landscape painting. Ironically, the strength of a painting may depend on a focal point as simple as a single tree. Artful composition can range from a dramatic contrast of mountains and valleys to the placid mood of water meandering through marshes toward the horizon.

It can be centered in a body of water such as a lake, where the eye will usually pause. It might be quietly evident in the path of a river that begins in a foreground and leads the viewer farther into the painting. A skillful artist can plot the course of an idea persuasively on canvas to draw the viewer closer to the artist's own response to nature.

The poetic landscape consists of more than materials and technique. While its subject is nature, the pattern is not nature's but rather the artist's arrangement of natural elements, which is often very different from reality. This order is rooted in the artist's sense of the aesthetic, and it includes unity, rhythm, balance, proportion, and integrity. Frequently, a serious editing of the unnecessary is required for the sake of clarity. Knowledge of nature is crucial because all components of the landscape are interrelated; it is

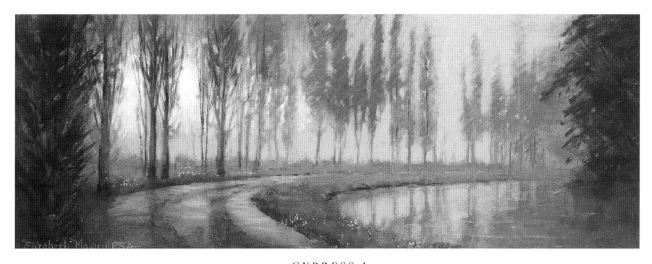

CYPRESS I
9 × 24 inches, pastel, 1999

A landscape painting must be taken in as a single entity. Diverse elements must add up to a pleasing whole. In this painting, the trees, sky, path, water, and reflections are unified by a sense of rhythm, balance, and harmonious color.

not just a matter of adding a field here or eliminating a few trees there. The artist must be mindful of scale as well as the consistent movement of light through the painting. Diverse elements must add up to a pleasing whole and have a focus. This is a cognitive process that is not required when the artist is fastidiously documenting reality, but that is not the topic we are exploring here. Even after the painting is begun, adjustments are made having to do with such things as the choice of color, contrasts, texture, brushstroke, and the treatment of edges. The artists most attuned to nature will be best equipped to make sound, intuitive decisions about when to change what is before them and where, in a painting, to use nature as it appears. In addition, the poetic landscape must embody the artist's mastery of execution for an impact to occur. The mind's eye must be able to glide over the landscape and all its components as one entity. When this happens it can evoke a harmonious blending of the present with memories on many levels, including sentiment, mood, and attitude, which all give dimension to our lives. If the eye hesitates, even slightly, as it moves across the painting because of clumsy execution, sloppy proportion, or an over-emphasis on color, edge, or brushstroke, the poetry is lost. The risks are always higher at the top. This holds true in painting as well. When a landscape is so close to the edge of poetry and fails, it becomes pathetic.

Where do humans fit in poetic landscape? Do we fit at all? We have interrupted the rhythm of nature effecting the atmosphere, our water, and plants and animals. Yet we can't deny our own existence. Each artist much choose whether or not to include people in the painted landscape. To be poetic, the peopled landscape works best when the figures are small and

NEAR ÉTRETAT
5 × 7 inches, pastel, 1998

To be considered poetic, the peopled landscape works best when the scale of the figures accentuates the magnificence of nature. In this study of hills near Étretat, the viewer can easily relate to the small, solitary figure.

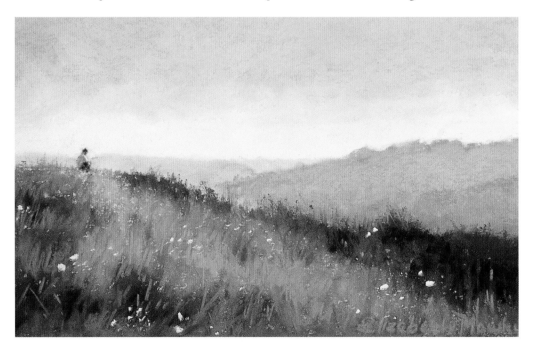

indistinct, thus accentuating the magnificence of nature. If a solitary figure within a landscape appears harmonious with nature, we relate to it. We become that figure. Corot and Inness were masters of this technique. Inness believed that "The highest art is where there has been most perfectly breathed the sentiment of humanity." When the figure is painted larger it becomes more important, and the nature of the painting changes, as in Cézanne's paintings of bathers.

In peopled scenes, we are eavesdroppers, on the outside looking 'in' or 'at' because someone else is already there. Unpeopled scenes invite us in more easily. Nature says, "Here I am, for you." Landscape can be very powerful and poetic at the same time when the figure is absent but human presence is reflected by the rooftops of a little village nestled into the mountain, rows of cornstalks in winter, or a fence sectioning off a corner of a field.

If human presence is part of a landscape painting, it will have more poetic impact when it is paired with a time of day that is also poetic. Visualize a bonfire at dusk, windows illuminated after dark, or fishing boats in a morning mist. Dawn and dusk are the times of day when we feel we are the first or last to be out and about and that nature is ours, not shared by others. When a painting skillfully depicts such qualities of light, it reaches people who are privy to those special times. If the human figure, or groups of figures, are painted with expertise and suggest activities we associate with the poetic, such

as gathering shells at dawn or a campfire kindling at dusk, they have the power to stir the senses in those who have had similar experiences.

The poetic landscape is a gentle, common landscape that speaks to everyone. When a deep connection exists between the artist and nature, it is sometimes possible to freeze a moment of that passion within the canvas or the sketchbook before it is gone forever. We will never recall many dreams and ideas that surface momentarily but are lost because of distractions that claim precedence on our time. Like fragile footprints in sand, they are so temporary, occurring only once before the inevitable tides wash them away. Poetic landscape can never be evaluated by its intent or the idea that spirited it. In the end, it is the painting that speaks or does not.

It must be made clear early on that poetic landscape is not always beautiful or nurturing. When it touches the core of a situation stemming from isolation, poverty, loss, or sorrow with dignity, it may very well be poetic.

While the photograph is essentially a documented fragment in time, a painting is the artist's response to a fragment in time. If it falls within the context of poetic, in its timelessness it can provoke a response from the viewer to a similarly remembered moment. In her highly regarded book on photography, Susan Sontag admits, "It is the nature of a photograph that it can never entirely transcend its subject, as a painting can."

THOUGHTS ON NATURE AS A SUBJECT

I prefer to walk alone, centered by stillness and the earthiness of where I am. My choice is to absorb nature rather than to discuss it. When I am expected to comment on some part of nature, the totality of the moment is shattered. I enjoy the company of others occasionally, but my communion with nature is solitary.

I have learned that even the most ordinary things in nature are different every day. When I notice some new aspect of the most common thing, the joy of this small discovery is a thrill more wondrous than when I come upon something unusual. I do not go into the woods to identify a list of things because that would prevent me from seeing anything else. I go to the woods with a feeling heart, expecting nothing, but I always return fulfilled.

I strive to see nature with an intelligent simplicity, not as I did when I was a child, but as a mature person, capable of assimilating and then sorting out what is most important. Nature uplifts the spirit, and because we all have a unique past, we extract what we need based upon our personal differences.

I know that seeing deeply is a state of mind and soul that develops, and when I see in a landscape that which mirrors my thoughts, I know I am beginning to find my poetry.

Although nature is there to inspire all of us according to the wealth that lies within ourselves, I have come to believe that only the first glimmer of an idea for paintings and poetry comes from outside. Afterward, for me, there are long evenings to sit by the fire and quietly witness my thoughts merge with past memories then take root and grow from within.

Today I invite the blustery winds to play havoc with my hair. I savor the touch of soft watery earth moving beneath my boots as I walk through the last patches of snow. I see the yellow violet and smell the wild onion. I remember walking along the heathered cliffs of Scotland. I am storing up my mind's portfolio with images, and they will return to me in a multitude of ways, as backgrounds and foregrounds in my paintings, as peace and stillness in my heart.

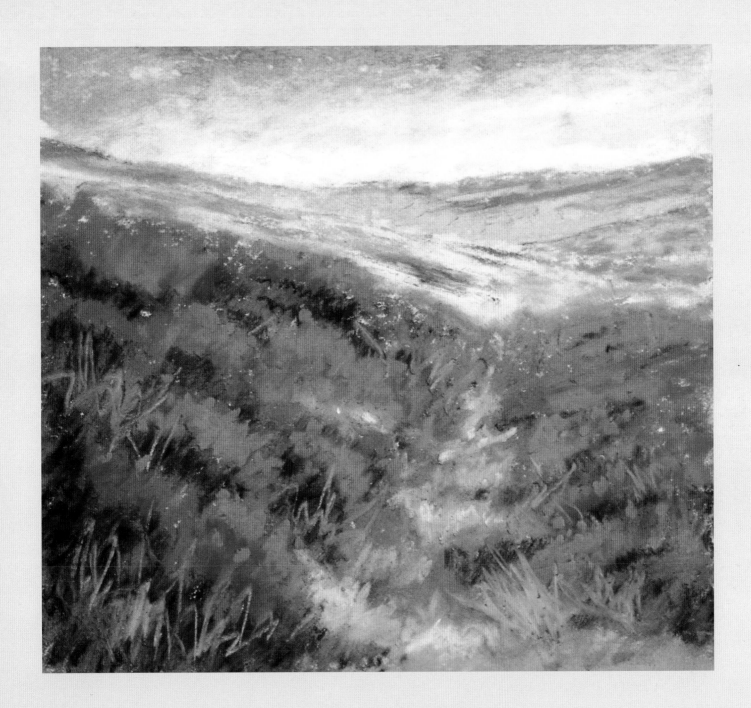

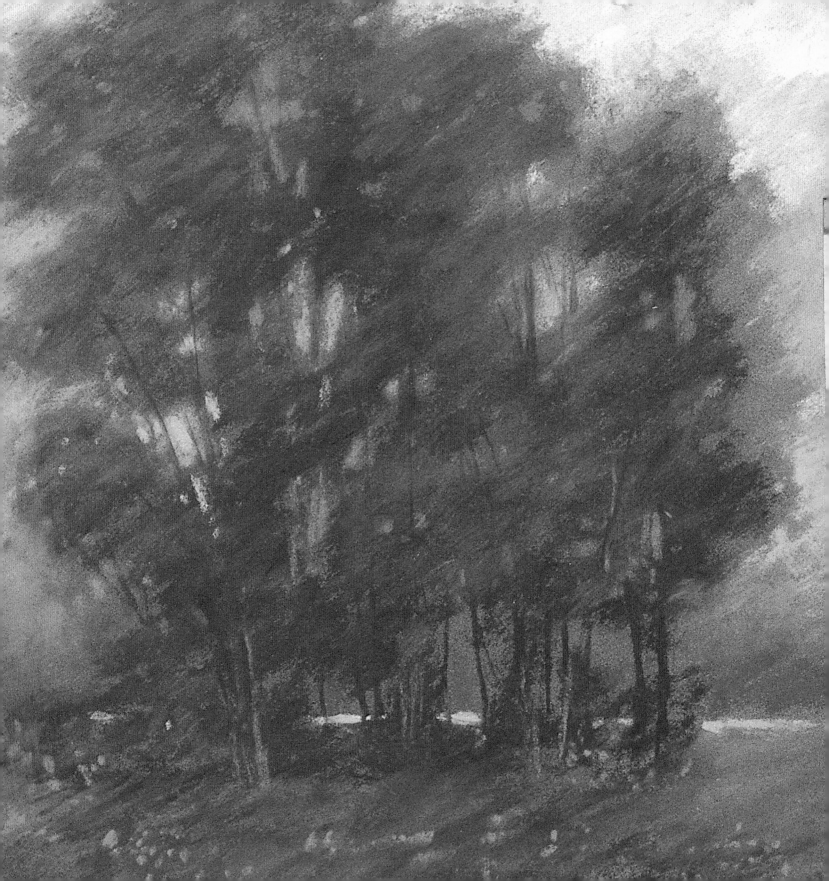

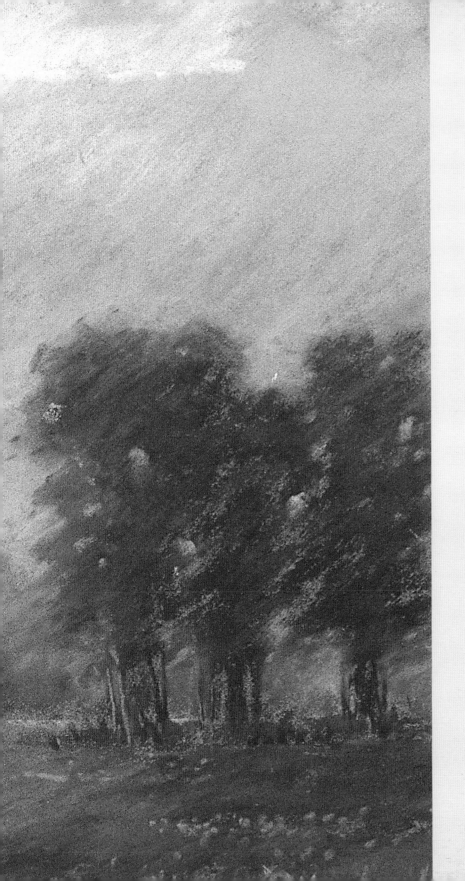

CHAPTER 2

The Concept

"Every artist who . . . aims truly

to represent the ideas and emotions

which come to him when he

is in the presence of nature

is a benefactor to his race."

GEORGE INNESS

"The aim of art is to represent

not the outward appearance of things,

but their inward significance."

ARISTOTLE

Art based on nature bridges all cultures. Humans differ in race, beliefs, and language, but all humankind relates to the land that sustains it. By what it is—visually edited nature—the poetic landscape empowers itself with the capacity to satisfy the individual's need to arrange emotional experiences into understandable patterns. As a result, such patterns provide people with insight that is unusually poignant. The poetic landscape can connect us with features of our lives that we might otherwise pass by. In essence, the painted poetic landscape represents the state of grace that in our longings we search for and aspire to.

As early as the 1830s, Ralph Waldo Emerson, a fervent advocate of the simple life, wrote that we set a high value on "wealth, victory, and coarse superiority, and yet still experience less and less tranquility." At about the same time, and coinciding with humankind's looking to nature for contentment, the

growing popularity of landscape painting was in place. According to a recent poll, more than 75 percent of Americans claim they would like to simplify their lives. Ironically, as a result of marketing research, we find ourselves in the midst of a frantic, money-making movement to eliminate clutter in our lives, our minds, and our space, which has been labeled "the simplicity movement." As we strive toward a less stressful pace in our everyday living, the words of Thoreau echo with the persistence of a droning mantra: "Man is rich in proportion to the number of things he can do without."

The poetic landscape, which is a version of reality edited by the artist, is a gentle reminder of the existence and importance of tranquility. In addition to symbolizing a balance in physical and emotional health, in it can be seen a metaphor for clarity of thought. Emerson was fond of saying that "there are

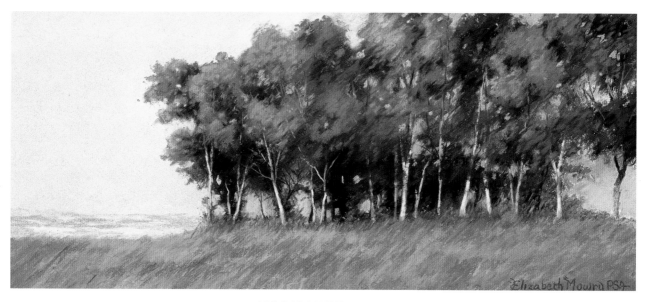

NORMANDY HILL
8 × 18 inches, pastel, 1997

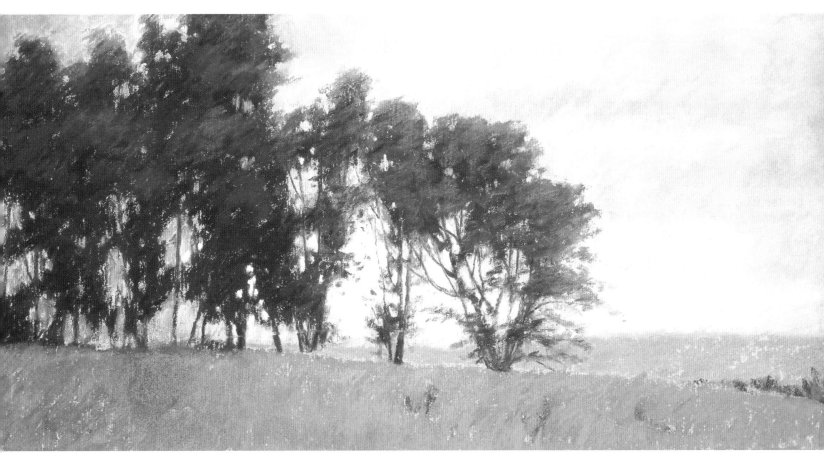

CHILLINGHAM HILL
7 × 13 inches, pastel, 1999

All people easily relate to the land that sustains them. These two views were painted in different countries, but the underlying concept is the same.

In Normandy Hill, any activity that may exist in the distant village below, barely suggested on the left, does not interfere with the peaceful solitude symbolized by this group of graceful trees in a field of windblown grasses.

After touring England's Chillingham Castle and its gardens, I chose to paint an interesting stand of trees at a far corner of the beautiful estate. The artist can visually edit nature to suggest what is universal. Such patterns can provide the viewer with insight that is more poignant than usual.

voices which we hear in solitude, but they grow faint and inaudible as we enter into the world." How frequently it is that a walk through the countryside restores our equilibrium.

When we apply simplicity to art, we are not referring to the undeveloped or the unevolved, but to the elegance of the unencumbered. Some of the most simple landscape subjects yield the most poignant images: a field of lavender, the designs water makes over a flooded plain, or a leaning tree. Overgrown pathways are another example: They beckon people toward places normally unavailable and where only a feeling heart will go. Simplicity in art is the elimination of the unnecessary. Plato said, "Beauty of style and harmony and grace and good rhythm depend on simplicity."

SHORE PATH II
9 × 9 inches,
pastel, 1995

This little byway could be almost any- where along a coast where white sand con- trasts with the dark greens of coniferous trees. Simple subject matter can yield images that make a strong impression.

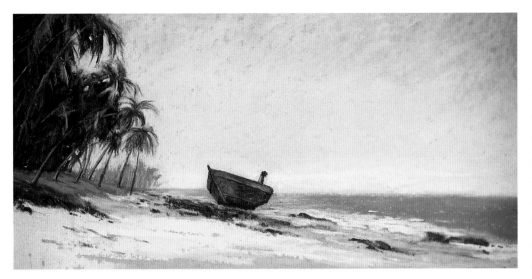

One of the things we first notice about a poetic painting is that it declares the beauty of a singular idea—one moment in time. If we, as artists, hope that our work will strongly affect the viewer, we need to put thought into what in nature strengthens the concept of our painting. And we need to know what constitutes a diversion from it. Just as when we simplify our lives, we need to fortify ourselves with the clarity of thought that gives us the courage to throw out useless bric-a-brac. The process of deciding what is or is not important requires a period of thoughtful reflection. Ultimately the artist benefits from an evolving sense of illumination that is passed on to the beholder.

When an artist decides on a single idea, sometimes reality must be edited severely; the painter's canvas is small compared with nature's. When a painting's concept becomes clear it is easier to decide what elements to include and which colors and painting techniques support the concept and which do not. The same process applies as we near completion of a painting and begin to consider details. If detail does not enhance the composition or support the main idea, it is generally best to omit it. Limiting detail, or including it selectively, allows the main idea to retain its importance. When the viewer is distracted by a collection of meaningless fragments, even beautifully executed ones, focus is shattered. Life is not about fragments. Neither is a powerful painting.

Some artists possess the uncanny ability to isolate one moment in time by painting a place in a way that the moment becomes timeless. If they have the talent to portray it with integrity, honesty, and passion, the work will be exceptional. Here a poetic landscape painting is a sharing of the beauty found within an impression and the artist is able to zero in to the core of an idea without wavering. Other ideas will arise during the process because the artist's mind remains open. However, each new idea that surfaces is carefully weighed to see if it strengthens or weakens the major concept.

The poetic landscape painting does not confront the viewer with weighty messages. Heavy political,

social, or economic issues do not plead for justice. Neither angst nor anger spill from the artist into these works. Frustration and anxiety have no place. However, neither is the poetic landscape dreamy or weightless. No saccharin prettiness oozes from its surface. As a biographer of George Inness noted, the revered poet of landscape "never allowed sentiment to deteriorate into mawkishness."

Complicated, vividly colored, detailed landscape compositions tell the viewer many things. They are like one-sided conversations telling what the artist has seen and where the artist has been. Some are lovely sharings; some are unabashedly self-centered. The less we dictate in our paintings, the more we compliment the beholder's intelligence. It is as though the artist is saying, "Come. Be at peace with your own thoughts and experiences. They are as valid and as important as mine." The poetic landscape invites another human being to enjoy the view based on what lies within them. It is an other-centered gesture.

While it holds true that the painted poetic landscape encompasses only one idea, even then the best of those merely approaches closure of that idea. It is comparable to stepping aside to allow your friend the opportunity to pick the flower when there is only one, when in fact you could pick it and hand it to your friend. By stepping back, you give more than the flower. You offer the gift of choice by withholding your own assumptions. Your friend then may notice and comment on the flower, smell it, pick it, or whatever.

When a painting tells the whole story, the invitation for personal connection dissipates. A vague disappointment lingers. Too much reality closes a door

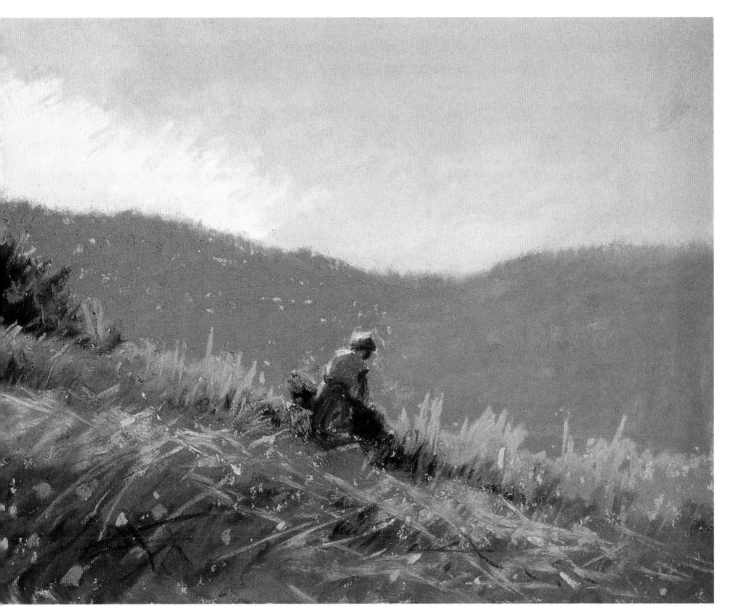

HAY GATHERING

5 × 10 inches, pastel, 1995

When I saw this woman gathering hay on a Swiss hillside as I hiked through the Rhone Valley, I knew that the impression would stay in my mind forever. A poetic landscape painting shares the beauty found within an impression. There is no completed story here, just a very simple visual statement that the viewer may relate to on many levels.

that if only left ajar would intrigue. In fact, when landscape painting composition evolves from abstract design, and some of the abstracted pattern is retained in the finished painting, intrigue intensifies. It gives the viewer a wider range to interpret the painting in a way that suits personal needs. When the work is extremely abstracted, sometimes people cannot relate to the painting at all. Then they may enjoy the design, color, proportions, and balance of a piece, but often they will be unable to make personal connection. Poetic landscape by the sensitive artist can help people attach cultural, intellectual, or sentimental meaning to nature to adjust their visions and consequently mend or enrich their lives.

While photographers can record even the most complicated scenario, including fast-moving split-second action, painters have an advantage when it comes to editing reality in landscape. They can omit telephone wires, electrical towers, and the litter floating in a pond. They can fill out the foliage in a tree after a storm has damaged it, put the fallen petals back onto flowers, take people off paths, and put deer in woodlands without shivering for hours until the deer really appear only to bound and leap away. The artist can take liberty with loosening a rigid fence, removing a limb from a tree, planting some birches along the stream, or relocating the concession stand in a park (without going to jail).

LATE AFTERNOON
11 × 27 inches, pastel, 1997

In this painting verticals are placed on a horizontal line making the shape of the sky interesting. That was the idea I began with—a simple abstract armature upon which I draped further interpretation. Whenever I begin to entertain many ideas about one subject, I set them aside for separate paintings. I have learned that impact is always compromised by inserting afterthoughts into my work. Here negative sky spaces become prominent as color temperature warms the painting.

KALEIDOSCOPE SKY

24 × 28 inches, oil, 1997

Dramatic color in the sky suggests early evening. The light on the distant meadow is echoed
by the horizontal band of light in the sky. The mood becomes exceedingly quiet.

AUTUMN AFTERNOON

15 × 30 inches,
oil, 1997

*In this oil painting,
the nearly centered
group of trees and the
use of complimentary
color take the viewer's
eye back to the hori-
zontal light on the
far field.*

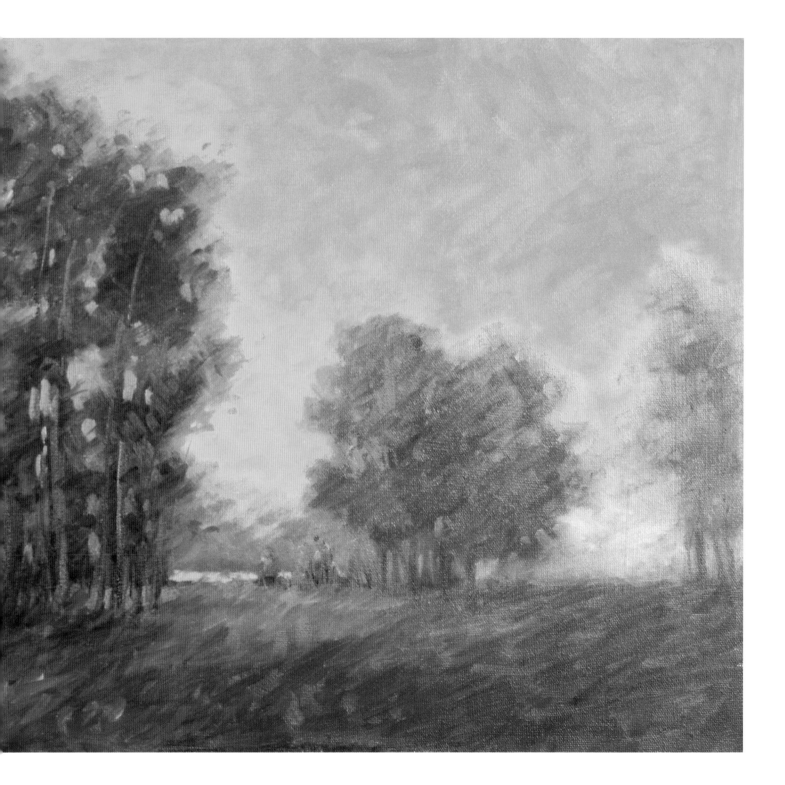

The photograph has been aptly called an unpremeditated slice of the world. It is an unretouched documentary of what exists at any tick of the clock. The interpretive painting, by its entirely different nature, is that much better a painting if it is not simply a glimpse of reality flattened onto a canvas. In Susan Sontag's classic *On Photography* we find Edward Weston's wonderful quote: "What photography did was liberate the painter from the task of providing images that accurately transcribe reality. For this the painter should be deeply grateful." Man Ray said more than once, "I photograph what I do not wish to paint, and I paint what I cannot photograph."

As we determine how important concept is in painting, particularly in landscape painting, we must clarify what "concept" means. We need to make a clear distinction between a photographic copy of reality and the painted interpretive image. That done, we can appreciate the union of the painted image and the place itself. In other words, the painter's role in the partnership between humans and place has less to do with portraying specific natural elements and more to do with essence. A concept, according to Webster, is a general idea or thought. It might represent a sentiment, a feeling, or be based upon a memory, or even a dream. How a concept emerges to consciousness has always been difficult to understand. About facing the blank page, Keats wrote, "Then on the shore of the wide world I stand alone." But it seems true that once the seed germinates it begins to crowd our thoughts until we pay attention to it. An idea is a form, a mental conception of a thing as opposed to its reality. Especially in the case of poetic landscape, the concept or idea must be general enough for the the viewer to transfer his or her own feelings onto the scene. Examples that we are all familiar with would be the path or road as an invitation through or into a space; a sunlit meadow barely visible beyond shaded trees that promises a place for a picnic; or a plowed field that tells us of humankind's peaceful coexistence with the earth. Simpler examples include the end of a day, the crumbling of a stone wall, a dialogue of wind and blowing grasses, or a broken fence. All of these have a story. The painter puts the idea on the canvas, and the viewer finishes the script. Ultimately, this whole constellation of visual concept works best when it is least obvious, when the beholder isn't even aware of an underlying notion of the artist. Sometimes even the artist isn't aware. The sentiment that joins the viewer with the painting is uncontrived and pure: The viewer simply feels an attraction to the painting because of what it means to her or to him.

Balance cannot be stressed enough when we think in terms of poetic in all creative forms. The most captivating characters in all literature are the most complex. What makes them human is a spellbinding combination of good and bad. Masterful authors keep us on the edge as they illuminate incidents and weave a tale that takes many directions before it concludes as the author intended. The most memorable films are those that catch us smiling through our tears. Puccini's opera *La Boheme* eloquently straddles the edge of comedy and tragedy. So it is with painting. When nature is painted in such a way as to dance in the space that divides joy and sorrow, or abandon and reserve, we know the artist has succeeded in touching that same elusive window of our soul's yearnings.

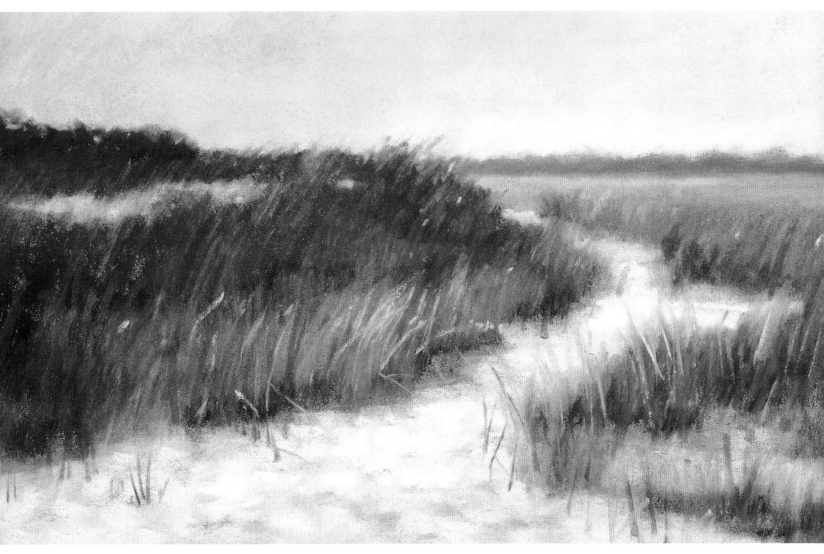

DUNES

6 × 9 inches, pastel, 1995

Nearly everyone can relate to narrow paths through sand dunes. Although curves suggest the unhurried pace of those who walk here, what lies beyond the final turn becomes a playful mystery. The viewer will transfer personal feelings onto the scene and finish the story.

THOUGHTS ON THE CONCEPT

One snowy day, a friend told me that he had been out for a drive in the country that morning and saw some things that he was going to attempt to write a poem about. He went on to describe a cow that was standing very still near a fence in a field. My friend stopped his car and watched the snow continue to fall on the cow. The cow didn't shake or move. Its huge liquid brown eyes fastened on my friend who described this suspended moment so eloquently and yet so directly that I couldn't shake it from my mind: It was the ultimate metaphor of a gentle, stoic acceptance. This is what the greatest paintings and the most celebrated music is about. It is what poems are. My friend did not need to attempt to write the poem. He already had. And what made it possible was that everything—all the complexities, all the bittersweet disappointments, all the challenges met— that had already happened in his life to that point had made it possible. What we are often leads us to the poetry we find in everything: nature, music, life.

Having a jigsaw puzzle on the table between Christmas and the New Year has been a family tradition for many years. Family and guests walk by and place a few pieces or sit for hours. I don't know how or why it started. I believe it had something to do with the space between an ending and a beginning, the mindless relaxation savored before everyone moves on and emptying the cup to make room for it to fill again. When my children were small I frequently unwound working on a puzzle in the late hours after they were asleep, and I was often the one who set the final piece in place. But I always removed about ten or twelve puzzle pieces again before going to bed. The next day, watching some little hands excitedly tapping the final pieces again with great satisfaction was a double joy for me.

There is something about closure, the obsession we have with attaining it, the satisfaction of possessing it, and the finality of ending the quest that correlates with the poetic landscape painting in which the painter presents a scene that invites the viewer to enjoy the satisfaction of inserting the final pieces of script into the story.

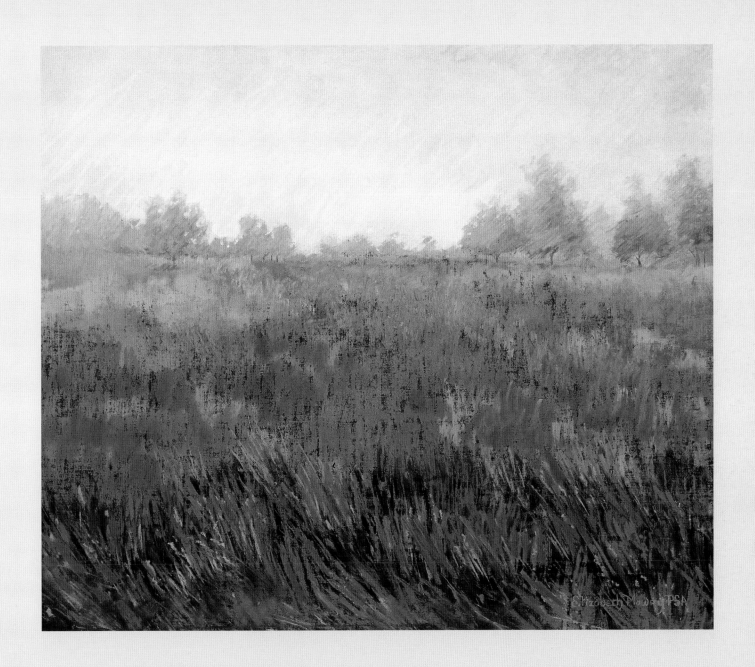

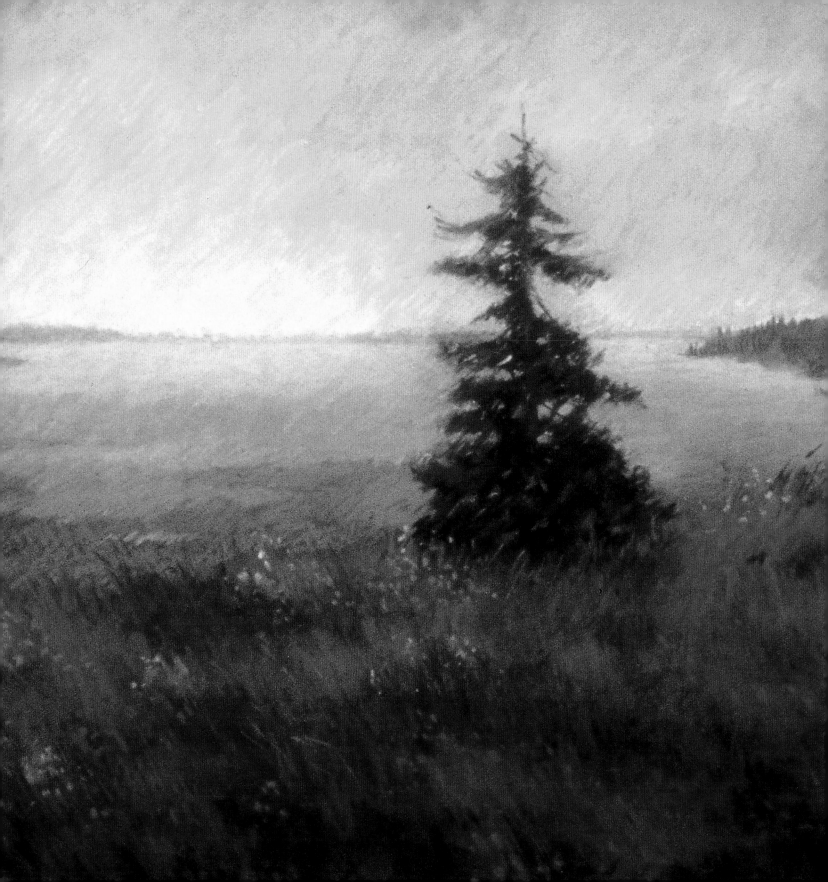

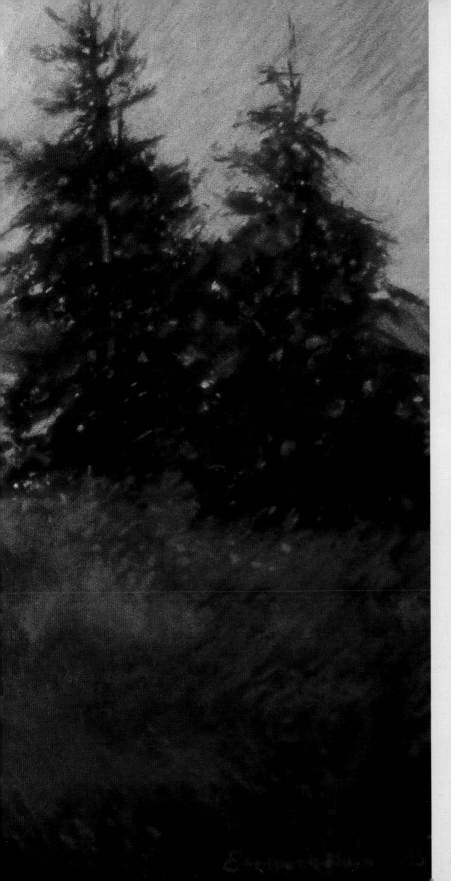

Color

"Color creates form.

The eye and soul are caressed

in the contemplation of form

and color. The subtle changes

of color over a surface . . .

transitions that are like music . . .

are intangible in their reaction

upon us. There is an immediate

sensuous appeal."

JOHN F. CARLSON, N.A., *CARLSON'S GUIDE
TO LANDSCAPE PAINTING*, 1929

Within the past one hundred twenty-five years, research on color has resulted in an entire field of study called color psychology. The topic is immense and its implications effect all areas of our lives.

Color recognition is the very last part of our vision to develop. It is preceded by the ability to distinguish contrast, the ability to see movement, and the perception of shape, in that order. All of these also play a role in our reactions to color.

Before the nineteenth century, it was difficult to produce a wide variety of colors. Now science and technology make it possible for manufacturers to produce all variations and intensities of color for the products we use every day. Each year decorators and designers announce what colors are in or out of fashion. The colors of the clothing we wear, the home furnishings we choose, and even the cars we drive are based on marketing research. There are books, videos, and television programs that show us how to coordinate the color of the plants in our gardens, the tables we set, and the foods we serve. Color is a thriving big business. While we purposefully select hues to enhance our personal space according to individual preferences, we do not control color in public places. When aggressive competition for our attention and our money exists, we can be assaulted by color that can even effect us in detrimental ways physiologically.

More than twenty years ago in Germany, Dr. Max Luscher developed a simple, accurate test that is still used today to determine signs of stress in humans. It is a valuable tool used by physicians to provide early warning of ailments such as cardiac malfunction, cerebral attack, and disorders of the gastrointestinal tract. At a time when prevention of disease through healthy lifestyle is emphasized (along with a positive attunement with the environment), it is easy to understand why results are also applicable in areas of psychology, vocational guidance, industry and commerce, just to name a few.

The psychology of color and art are closely related because color, or absence of it, is an essential and conscious part of art. The colors used in landscape paintings are nature's colors. They are not controlled by man or by the market, except for the color of man-made things such as barns, houses, or bridges. When landscape painters attempt to copy nature rather than interpret it, their choice of colors is less personal. An artist's selection will be rooted in preferences based on experiences and on skills such as mixing and juxtaposing color and attaining the desired color temperature and intensity. It would be interesting to investigate why artists favor certain colors, but here we want to evaluate the impact of color from the perspective of the observer who has a different set of personal life experiences than those of the painter.

All people are emotionally sensitive to color, some more than others. Certain colors are associated with universal psychological and physiological meanings. However, because we are all biased in our selection of expressive color, it is interesting to look at what some studies on color have revealed. The short form of the Luscher Color Test involves eight colors: gray, blue, green, red/orange, yellow, violet, brown, and black.

It's not surprising to find that gray is considered neutral and free from all stimuli. It represents uninvolvement. Applied to landscape painting, gray or gray blue is used to put parts of a scene into the

distance so that we are less involved with those areas than with the more active and colorful foreground.

Blue has a calming effect and is considered the color of healing power. It has been found to reduce blood pressure, pulse, and breathing rate, and people who are ill or physically exhausted find it to be restorative. Often blue is used to symbolize beauty, and it is believed by many to be the color of transition between the physical and the spiritual. According to studies of color and energy, indigo represents a basic biological need for tranquility and contentment and has been found to evoke a longing for solitude. In a painting of reflective water or of foliage shadows, dark blue may arouse subtle feelings of empathy, loyalty, or balance.

Green is believed to represent perseverance, self-affirmation, constancy, and resistance to change. In a landscape, use of warm and cool greens in a

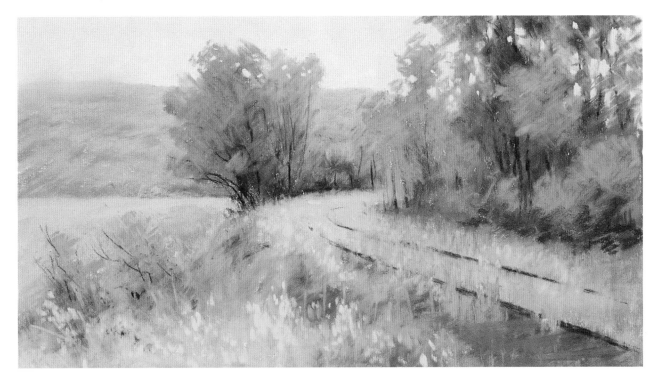

SPRING STUDY
5 × 10 inches, pastel, 1999

Spring Study is a high key painting of a railroad track that obviously is no longer in use. High key means that the colors used are in the upper (lighter) range of the value scale, and here that conveys the season of spring. Many factors are involved in communication between artist, canvas, and viewer. It is more than a matter of setting up an easel outdoors on a sunny afternoon and painting what is there.

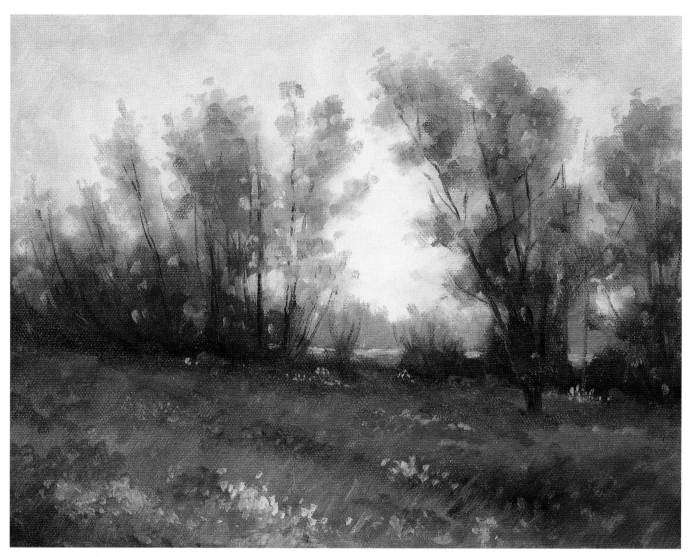

WILLOWS
9 × 12 inches, oil, 1998

The gracefulness of the trees and the gentle slope of the hill in Willows *are already interesting, but the few bright yellow flowers scattered in the foreground add a welcome color note to the scene.*

foreground might symbolize a sense of greater activity in relation to the rest of the painting. Green is considered by many to be a balancing energy. In nature it also represents the renewal of springtime and the growth and abundance of summer. Terms such as "green theology" are used by ecologists, spiritualists, and environmentalists to represent mankind's connection with all that is natural. Pleasant associations with the greens of a summer landscape may be rooted in the change of pace we link to our summer vacations. Skillful use of greens in landscape painting will pull areas together and facilitate harmonious transitions between differing elements such as rocks and trees and water.

Physiologically, red and orange are known to speed up the pulse, raise blood pressure, and increase the breathing rate. They suggest desire, vitality, competition, and productivity. While orange is an emotional stimulant that evokes feelings of courage and power, red represents a desire for intensity of experience and fullness of living. A painter's skillful use of red or orange in a landscape painting will enliven the painting and direct the eye. When paintings of brilliant autumn foliage or an arid desert under the glow of a warm sky do not work, it is usually due to the painter's lack of experience in expressing the intensities and refinements of color nuances. We have only to recall the exquisite landscape paintings by George Inness to know that nature's brightest colors can be painted with poetic subtlety.

Yellow is a color most of us associate with light, cheerfulness, and expressiveness. Psychologically, it can induce feelings of release from burdens or restriction. It corresponds symbolically to the warmth and welcome of sunlight and spontaneity. A painting of quiet rolling hills under a blue summer sky might be enhanced by a lively color note of yellow buttercups snuggled in the grasses. For the artist, yellow is a strong color that must be handled with control because it has the equal capacity to enhance or overpower a landscape.

According to Luscher, violet "unifies the impulsiveness of red and the surrender of blue into a mystic sensitivity or enchantment." Some health practitioners regard violet as the color connection beyond physical energy to divine energy. Others believe that violet facilitates intuitive understanding. Leonardo da Vinci claimed that "our power would increase tenfold if we meditated under the violet stained glass windows in the cathedral." Violet, already a mixture, is useful to the landscape painter when integration of other colors becomes important.

In a painting brown does not call out for attention. It is a receptive rather than an active mixture, and it accepts its place as a support for more impulsive or vibrant colors. Among artists, brown is quite often regarded as "mud," a diluted or overworked statement that cannot be made vibrant again, and in their paintings, artists will frequently replace local brown color with a more innovative color.

Black is the negation of color. Unless it is used sparingly, pure black is capable of overpowering a landscape painting. Mixed in small amounts with other colors, however, it can beautifully soften hues to represent those we frequently find in nature. Even though part of nature's cycle has to do with death and decay, we would normally be cautious about using pure black in large areas because it fails

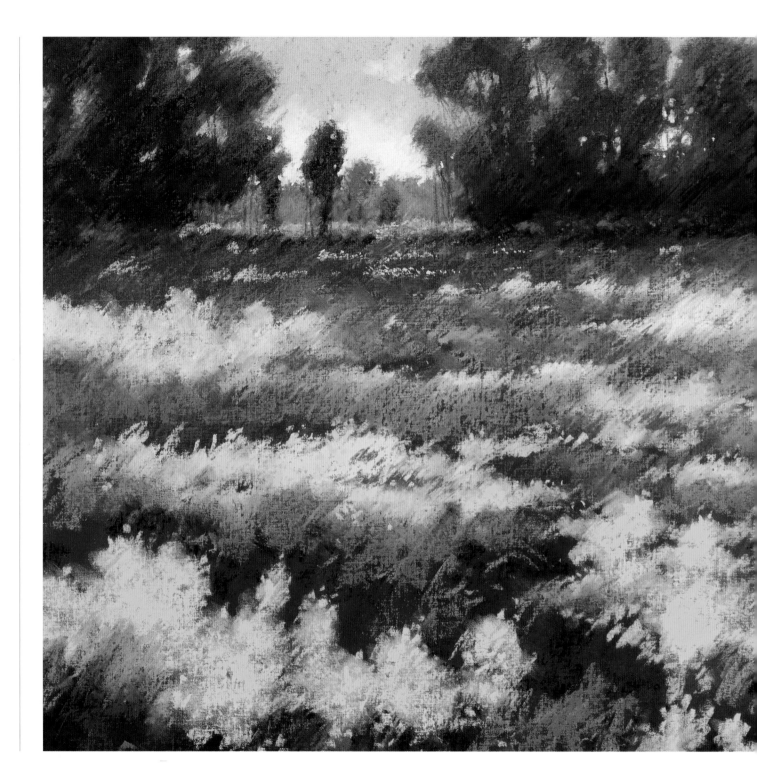

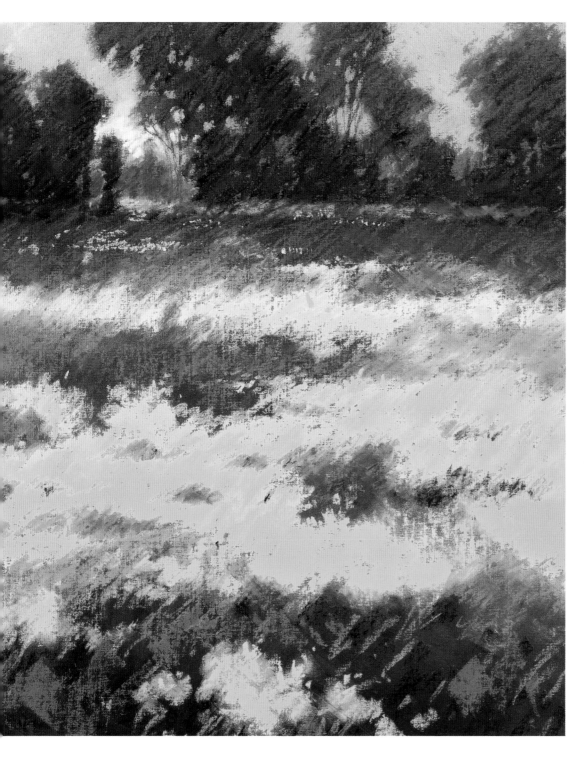

MUSTARD FIELD
20 × 36 inches, pastel, 1994

Yellow is a strong color that in its pure state can either enhance or overpower a landscape. Artists adjust temperature and chroma as well as the amount and position of color to achieve the desired effect. Varying amounts of a color—here yellow—has a significant role in the outcome of a landscape painting.

In this large painting of a mustard field, blue and purple are used in the distance and then repeated in the foreground. The loose stroke with which the foreground is applied keeps the painting from becoming stiff and contrived.

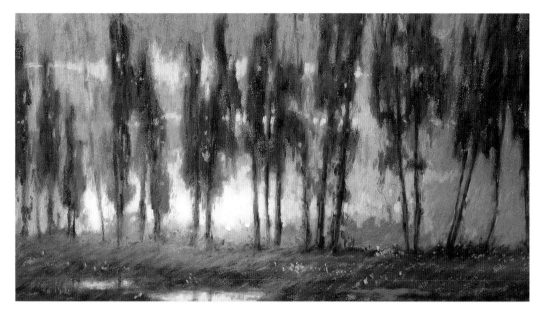

CYPRESS #4

8 × 15 inches, pastel, 1999

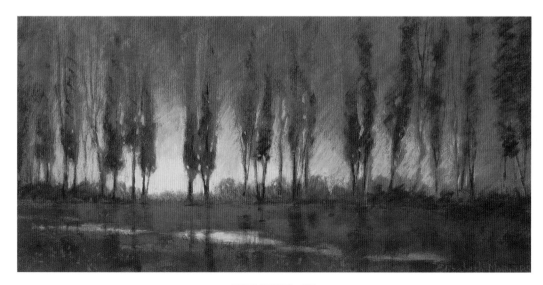

CYPRESS #3

8 × 18 inches, pastel, 1999

Cypress #4 *is a tonal example of seductive simplicity. In it and in* Cypress #3 *the subject matter and the idea are the same.* Cypress #3 *elicits a different response because the color and temperature of the sky alter the landscape as well.*

to acknowledge the other parts of the cycle having to do with renewal and maturity. An isolated black area in a landscape painting will pull the eye into the dark space and prevent it from moving through the painting. Where very dark contrast areas are important to composition, they will retain a sense of life and movement if they are painted with deep values of violet, blue, or green rather than black.

The tonalist approach to landscape painting has much to do with diffused light and subtle color gradations created by atmospheric effects such as the veiled mists in the paintings by George Inness that emphasize mood. Especially when cast over a site that cannot be precisely identified, mood lends itself readily to the gauzy visions created by Inness after the 1860s for which he was so highly revered. The compositions of Corot, another harmonist rather than a colorist, are also seductive because of their simplicity of color.

When we begin to explore the psychological effects of color and the emotional response it evokes we realize what a captivating subject color is, not only for landscape artists but for anyone who truly loves and understands landscape paintings. A helpful clarification for the nonpainter is the distinction between local color and color used by artists in their interpretation of a scene. Amateur painters, as well as amateur viewers, will be more comfortable with local color, which is the exact tone-for-tone color of things as they appear in nature. As they become more experienced, painters begin to permit themselves to let go of this strict adherence to local color. They become attracted instead to landscape colors that speak to feelings. A sense of security accompanies this growing attunement to a different level of painting.

A landscape painting is most appealing (or, as artists comment to one another, "when it really works") when a color or set of colors empowers the idea in the painting. A fundamental truth of landscape painting, and of understanding it, is that harmonious expression through association is as valid here as in any other area of our lives.

The "key" of a painting is the tonal value of the colors used throughout the painting; they can be light and fresh or dark, brooding, and somber. This tonality of color sets the mood in a painting and can evoke a similar mood in the viewer. Visualize the sunlit, breezy paintings of Frank Benson showing girls in white dresses on flower-strewn hills overlooking the water. The lighthearted mood here is very different than the sensation projected by nature's great power in a painting showing a gray sky casting a dark shadow over a large rock formation. Again, and particularly in landscape painting, Carlson tells us, "There is one color tonality about any given canvas that more fully represents the idea of the whole picture than any other color scheme." When the skillful artist exercises choice of color key to correspond with the idea of the painting, the aesthetic response in the viewer will be more poignant as well. Masterful use of color in a landscape painting has to do with the strength of power in reserve; the power doesn't call attention to itself.

Of all the seasons presenting color pitfalls, spring ranks highest, and understandably so. When the winter earth is warmed by the sun and nourished by the rain it's easy to notice plants and foliage growing, even between the morning and evening of the same day. Color explodes as trees and shrubs

leaf out into fullness. Flowers and grasses spread over fields, and water leaps down the sides of mountains, bouncing up from rocks to catch the warming sunlight. Spring quickly transforms the earth with color that only nature's canvas can handle. The canvases of mortals, should they to be so naive as to attempt to copy nature's elegance during this season, are vulgar by comparison. However, when the energy of a landscape painting touches the heart of the beholder in a masterful and quiet way, without the use of shocking or bizarre color, we are witness to the poignant value of reserve as power. This type of conservation stems from a lyrical mastery rooted in confidence and a highly evolved artistic state in which the artist actually feels color and is capable of expressing the feeling.

If we were to analyze what we consider beautiful about color in a landscape painting, we would soon find that it is not the colors themselves or how many of them, but the position of the colors as they are placed near one another (juxtaposition), the proportion of colors placed in the large and small masses in the composition (balance), the lightness and darkness of the colors (value), the color warmth or coolness (temperature), and the subtle or abrupt transitions of color that accentuate or minimize form to create dimension (edges). Beyond that, we know that "beauty" has not ever been unequivocally defined and that the eye and the heart of the beholder attest to what is beautiful according to all that the eye has seen before and all the heart has felt in the past. Artist and beholder alike, according to how well they know themselves, develop tendencies toward certain harmonies of color that are appealing and comfortable. No one needs to know scientific data to apply color aesthetically to his or her "life canvas."

Color theories provide the artist with formulas and also aptly put the science of color with relation to quality and quantity of light into understandable terms. The more elusive role of color harmony in painting is subjective, having to do with such complex characteristics as preference, degree, and even personality. Research has revealed that while our emotional response to color is similar, the way we see color is not. This discourages definitive conclusions about color, but it does inspire ongoing reflection. It seems true that while many well-executed paintings are painted with a full, rich palette, many poetic paintings are not. When it appears that the entire color wheel has rolled through a canvas, the impact may be too scattered and the response too tense to provide the eye a quiet place to rest. Pure colors together create tension. Also the brighter the color in large areas, the greater the tension on the painted surface. The anxiety that color can create in a painting does transfer physiologically to the viewer as we have noted earlier.

Yet this is not to say that a poetic painting is a dull painting: Lyrical painting and beautiful color are not mutually exclusive. When your eyes rest upon a poetic painting, what you might notice is the artist's use of low-chroma, subtle color in large masses that are set off by a small amount of complementary pure color that acts as a color surprise within the restful landscape—an orange tile rooftop, or a spot of viridian in the jacket of a distant figure, or bright yellow sunflowers along a fence. Unquestionably, unified color is an important aspect of the poetic landscape. It determines the mood of a painting and

is the first thing a viewer will relate to even before being close enough to see what the subject matter is. When all the colors in an appealing landscape appear eloquently integrated, the artist may have preselected an analogous palette (one with related colors that are close to one another on the color wheel) in order to attain that ambiance. The artist may also have painted in such a manner as to leave parts of a uniformly toned surface show throughout the work. Tonality in painting has to do with color value, hue, and temperature, which are so interrelated as to whisper an atmospheric quality into the painting. The subtle beauty of the colors in such a painting are luminous in their exquisite relation to one another. Corot was without a doubt, the master of tone. As Réné Menard said, "What he sees everywhere is not what is in nature, it is what is in himself."

Another treatment of color that some find appealing in landscape painting is the pushing of color to the edge of, but not beyond, what would be believable under a certain quality of light. When light is the primary influence on color, it evokes memories in the viewer of a particular time of day, or season, or atmospheric condition. Being able to pirouette

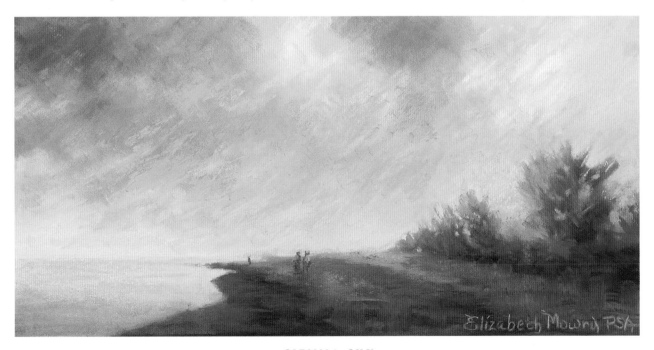

SIENNA SKY
6 × 12 inches, pastel, 1997

I painted Sienna Sky *with a limited, preselected palette of low-chroma color. The tiny color surprise in the shirt of one of the figures does not interfere with the overall ambience of the scene which, in this painting, was attained purely by a conscious choice of subtle hues. Unified color is one of the most important aspects of the poetic in landscape.*

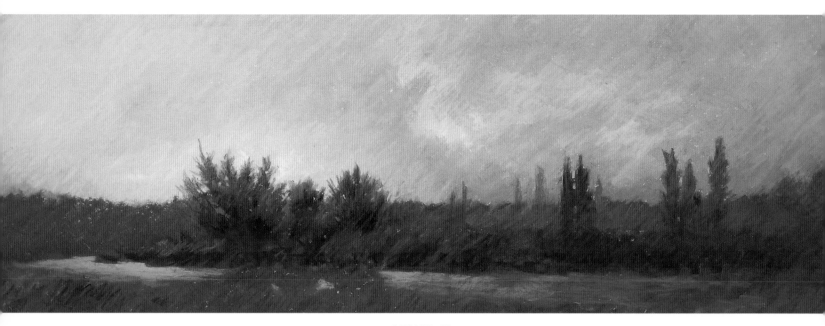

SEINE II
9 × 27 inches, pastel, 1997

along the rim of potential color disaster is a most exciting challenge for the landscape artist. Paintings that are successful in this rite of crossing are the ones that stir our souls.

When a landscape is well-composed, any colors can be used in painting it; the value and temperature of the colors will assume more importance than the name of the colors. There are times when the artist will enhance reality or intensify the overall color sense in a painting for a special effect. Even in poetic landscape, a quiet excitement can be attained by color overstatement as long as it does not become bizarre: The bizarre is a desperate and aggressive call for attention to itself and it cannot coexist with the poetic in landscape painting.

Nonpainters may find it interesting to learn that when an artist wishes to unify the color within a completed painting even more than occurred during the process itself, another color or colors can be introduced over the painting in order to integrate color throughout. With an oil painting this glazing is done with transparent gels or paints. In watercolor, transparent washes are used, and in pastel painting, the technique is called cross-toning. The purpose is to unify color in an already successful work; it does not help a bad painting.

You will have noticed that my thoughts on color and the poetic landscape have to do with harmony within a painting. Aesthetic balance appears to be an oxymoron at first glance because it most often has to do with bringing unequal parts or elements into harmonious proportion in order to establish equilibrium of the whole. For light and dark areas to balance aesthetically, they have to be unequal. The same holds

true for warm and cool colors and in the use of color complements, even in mixing colors that will not dissolve into grays. In the design of a masterful landscape balance is the support of opposites in unequal amounts so that the characteristics of all the unequal elements balance within the whole. This ultimately represents color harmony within the painting and is a first requirement for painted poetic landscapes.

Unequal, separate landscape elements such as reflective water, vertical trees, and horizontal fields can be skillfully combined into a unified whole when prime consideration is always given to, and remains with, the wholeness of the outcome. When an artist becomes sidetracked by precious attachment to any of the parts, or to isolated formulas, theories, or tricks, the viewer, who does not share a predisposition to those same attachments, will feel nudged off balance by the painting.

There are landscape paintings, and there are landscape paintings. When a viewer has had an opportunity to see all the paintings in an exhibition space and then steps out into the street thinking of only one painting, what lingers probably has something to do with the poetic.

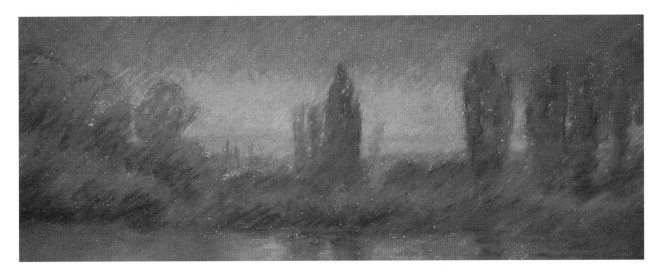

SEINE III
7 × 18 inches, pastel, 1998

Seine II *is a painting of a river at dawn. What was important to me were the sky colors and the quiet reflections supported by only the still darkened shapes of a minimal landscape. There are times when nature's colors are so exceedingly beautiful that we are seduced into spreading them all over our painting surface when just a little would be enough.*

Seine III was painted at the end of the day, again of the Seine at Vétheuil. The color was deliberately pushed toward the dramatic. In landscape painting the line separating the dramatic from the bizarre is often a fine one.

THOUGHTS ON COLOR

In spring, the Kukendorf Gardens in Holland are an annual attraction eagerly anticipated by tourists from all over the world. Growers plant spectacular installations of living color throughout the extensive park. Millions of yellow daffodils edge a meandering stream and wide paths of blue hyacinths wind through an extravagance of red tulips. Bold purples and lavish pinks weave intricate designs throughout hundreds of acres. Here fragrance and primary colors truly penetrate the senses. The Kukendorf Gardens are a showcase for this small, unique country's offerings that beautify the gardens of the world every spring. When I was in Holland I excitedly shot roll after roll of film. When I returned home, the photographs taken at the Kukendorf Gardens were those I put into my album. The ones I keep in my studio for quiet inspiration are those I took in the countryside along the roads that wind through the bulb fields of narcissi and tulips and hyacinths, each a single color stretching from foreground to the horizon punctuated only sometimes by the unmistakable shape of windmill arms far in the distance. This, to me, is Holland. This, to me, is color.

I have always been in awe of the power of color, and yet I use it conservatively. The colors I select for my home, gardens, and clothing are limited to those I feel most comfortable with. They are nature's colors, seldom primary. I admire the iridescence of an all-white garden at dusk. In one of my own gardens, I struggle to keep the yellows and the blues together. Another area has pink and white and purple blooms. Although I love to see orange poppies blowing in a field or a cluster of red peppermint berries peeping

through the pine needles on a woodland path I prefer bright color in small amounts, as strokes of colored light cautiously placed, such as the fuschia edge of a cloud, a blue-green highlight on an angled rock, and specks of cobalt in the violet grove. The nuances of each hue are what speak to me, and they are the same qualities that I want to explore, to experience deeply, and to weave into my life. It is the subtlety that excites me and draws me in to observe the intrinsic beauty of barely discernable differences, much like those of a delicate unidentifiable fragrance or a delectable mysterious ingredient—there, but ever elusive.

Early in my painting career I found that there was much more to color than just applying it to a surface. It became necessary for me to backtrack and carefully study the essentials of black, white, and the values between. I discovered that I was most intrigued by the play of one value upon another, the relativity and, in landscapes, the consequent disappearance and reappearance of edge. Realization that every color, together with light, has those same value differences is important now in the way I see and paint. I make friends slowly with each new color that I add to my palette. The process is much like a timid courtship as I observe what the color does in various situations and learn how it relates to other colors I already feel comfortable using to express a sense of place. I believe that each individual's appreciation and use of color is defined by something deeply personal. So often it is not a matter of how much color or how many colors I brush onto a canvas, but of how thorough my understanding is of only a few.

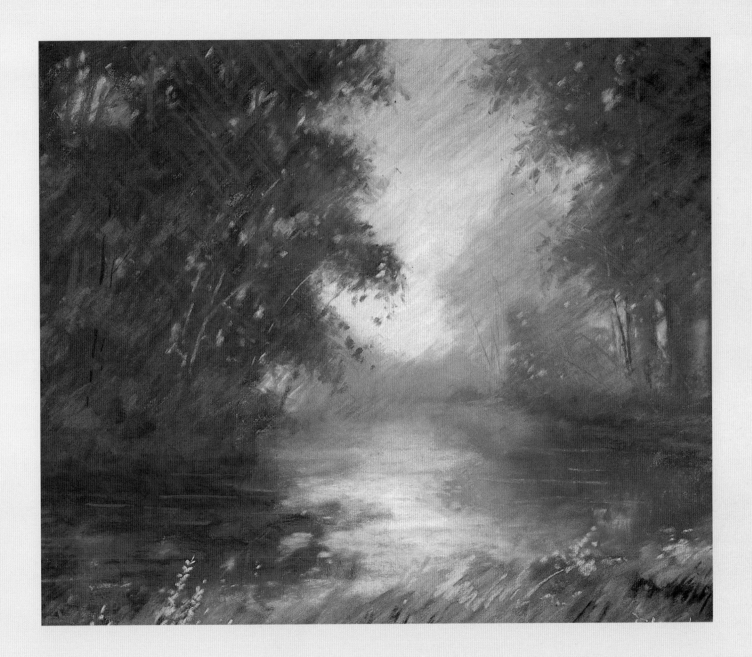

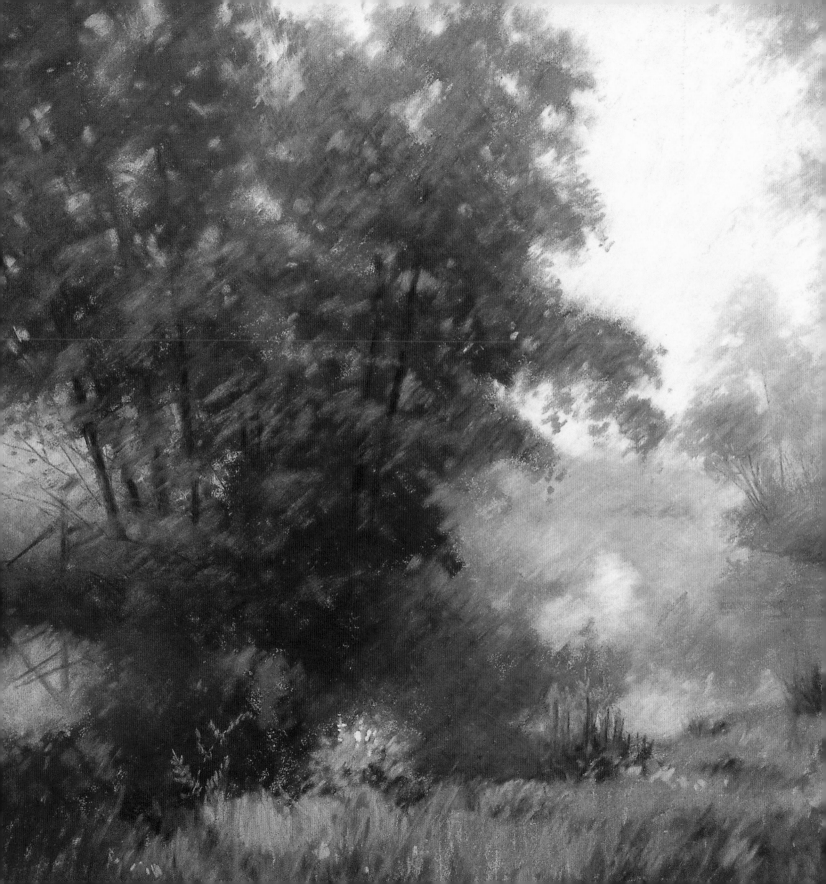

Time of Year and Time of Day

"It's morning and all is well.

I am . . . in the home of poets,

that is to say, in nature.

All the dewdrops of dawn glisten

through the delicate veil of mists

gently lit by the sun."

A BEHOLDER BEFORE A PAINTING BY COROT

TIME OF YEAR

Since the beginning of time, nature's seasons have been an affirmation of the four stages in the life of humans: birth, youth, maturity, and death. Seasonal change, paired with the assurance of a yearly cycle, constitutes an ongoing phenomenon of "variable predictability" with no definitive beginning or end. For humans, this translates into a recurring pattern of anticipation and memory, yet without monotony because as we mature we see each year from a new perspective.

The poetic landscape with seasonal content can provide a visual shortcut to tranquility while we struggle to reorder priorities or to resolve conflict in our lives. It assists in the understanding of our place in the greater scheme of things; it reinforces the fact that we are merely custodians of the land for a time; and it comforts us with a more kindly and less fearful view of death and loss.

We need only to observe a small, undisturbed wooded area for several years to witness evidence of nature's renewal. In winter, under a light snow, fallen trees are easy to spot. Nearby in spring seedlings will appear as the earth warms. They will mature into tall and slender saplings that bend with the wind. Years later, at maturity, the stately oak and the graceful spruce drop acorns and pinecones, and the process begins again. Even after floods and fire, the forest heals; meanwhile decaying trees, leaves, and pine needles enrich the soil where seedlings eventually take hold again.

Each season's beauty is beyond challenge, and nature's changes have always been a source of inspiration for artists. Yet of the hundreds of spring, summer, autumn, or winter paintings one might study, why might only a few be aptly described as poetic? Why, when the colors are true, the composition interesting, the perspective accurate, and the technique flawless? It may simply be that not all that is beautiful makes a poem.

In spring, the wet, warming soil pushes up marsh marigolds and glistening skunk cabbage. Then ferns uncurl. Forsythia and hawthorne and lilacs soften the stark forms of fences and barns. Budded shrubs and delicately flowering trees host the returning birds that begin their songs even before dawn. Days lengthen and warm moist air takes on the fragile scent of violets. Butterflies lift in circling pairs with every balmy draft of wind. For the technically skilled artist to put down the things noticed about spring with expertise is commonplace. It is not until the artist's selection and arrangement of those things begins to portray a thoughtful essence of spring that a painting approaches the poetic.

Balance plays a dynamic role in poetry. Balance is primal in life as well as in painting. For an artist to gather everything in a season that is beautiful and put all those elements into a painting misses the mark. There are so many colors in the springtime palette: the whites of dogwood and flowering pear, the pinks of azalea and rhododendrum and cherry; and the rich yellow of the sprawling forsythia. Spread throughout a park or an orchard they are beautiful. Something less enchanting happens, though, when too many of those young colors are painted onto a sixteen-by-twenty inch surface. Imagine serving three fabulous desserts on one plate. Separate, each

ORCHARD, SPRING

6 × 6 inches, pastel, 1999

Even the limited content of this small study captures the "essence" of spring. There is a short time in spring when both the apple trees and the wild mustard are in bloom. A watchful eye for this type of occurrence can be extremely rewarding.

is delectable; together, a culinary and gastronomic disaster. Too much of anything will artistically backfire. Some things are better simply enjoyed. Not everything has to be painted.

For all its beauty, the delicacy of spring's new growth can create an illusion of fuzziness, which on a canvas can quickly translate to weakness. Small flowery shapes need to be balanced by larger or

AT HOLY ISLAND
6 × 8 inches, pastel, 1998

The delicacy of spring's new growth can create an illusion of weakness on the painted surface. Sculpture works so effectively in a garden because small flower shapes need to be balanced by some larger or more structural form. The stone wall near the church and ruins on Holy Island provides a solid balance to the profusion of colorful flowers that line a path to the sea.

HURLEY CLOUDS
9 × 19 inches, pastel, 1995

Clouds over a landscape painted with minimal detail constitute a subject that most people would easily associate with summer. The low horizon line gives ample space to the main idea of the painting, which takes place in the sky.

more structured forms. This is precisely why sculpture works so effectively in gardens. What we must remember is that poetic landscapes are not weak landscapes by any means, nor are they whimsical or indecisive. The abbreviated potency of the genuine poetic is characterized by depth and strength.

After spring's rapid growth culminates in lush density, the summer landscape rests. Mature grasses and swaying wildflowers take on a gracefulness, and backgrounds recede into an unfocused blue haze. Cows congregate together under shade trees. The appeal of water beckons, and the still reflections of water lilies tap memories etched with water lilies of somewhere else. Color matures. The poet

Swinburne's lines come to mind: "The faint fresh flame of the young year flushes from leaf to flower and flower to fruit." The delicate scent of sun-ripened tomatoes and peaches and wild thyme permeates lazy afternoons. Sunflowers tilt toward huge cumulus clouds. The shadows of summer provide the rich range of values that the artist needs. When a painted summer landscape can capture the warmth and restfulness and grace of this season, and perhaps even the rumble of distant thunder, then it begins to approach that tenuous edge of reality where poetry resides. When the voices of other summers whisper through a canvas to the viewer, it has hit the mark.

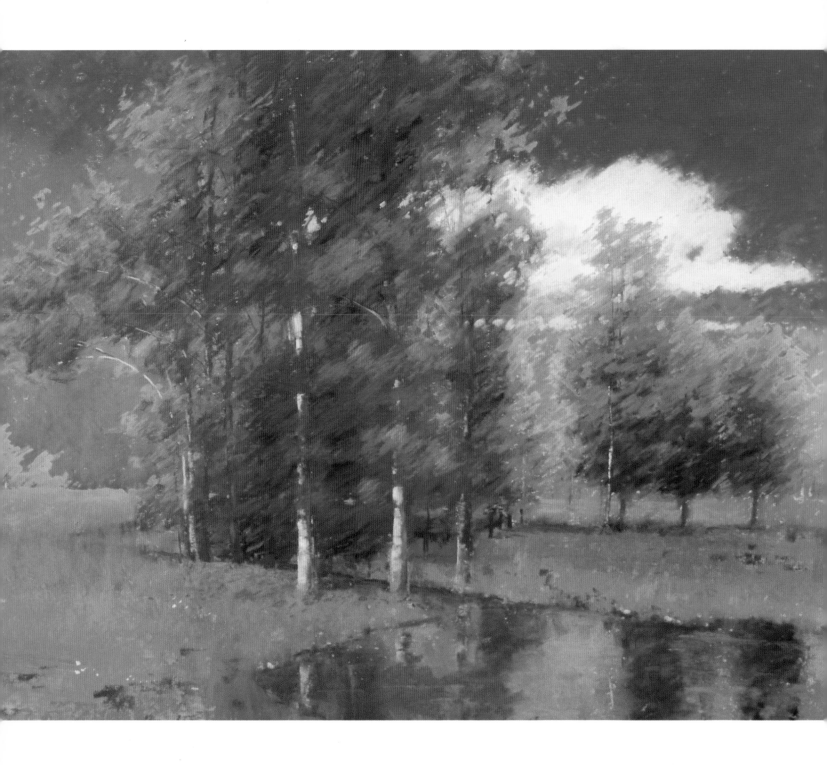

Autumn brings a final flourish of color before winter. Sun-dried fields turn ochre and seed pods open. Turtles pile up on logs in swampy marshes for final conversations. The cornstalks are cut, and the pumpkins are gathered from twisted, withered vines.

ABOVE

COMPOSITION STUDY FOR TOSCA'S VALENTINE

7 × 8 inches, pastel, 1997

OPPOSITE

TOSCA'S VALENTINE

21 × 27 inches, pastel, 1997

In Tosca's Valentine *I tried to convey all the splendor of autumn in a single tree. I brought the color values of the sky and tree closer together along the top edge of the painting so that interest would remain centralized in the red tree. If other autumn colors had been introduced, the resulting tension would have destroyed the idea of the painting.*

Compare this to the small study done on site in summer. Both paintings work because reality has been edited to achieve a strong composition.

Finally, even the fields of magenta loosestrife fade. Only the goldenrod lingers a while longer. Autumn is the season of maturity. Art inspired by this season will frequently remind us of our own maturity coupled with thoughts of mortality. Our compassion for all of life deepens. In order to live fully, this bittersweet reminder, sometimes triggered by a poetic landscape, can be a timely admonition.

At first, the discerning eye will harvest the minute daily changes of all seasons. We can learn from the poets here. In one of his sonnets Shakespeare writes eloquently of autumn, "that time of year . . . when yellow leaves, or none, or few, do hang upon those boughs which shake against the cold." After a time the attentions to details will merge to form a unified visual concept of the particular time of the year.

In autumn, particularly in the northeast where flaming maples grow in the same soil as the dark pines that hold the only color they know, their reds and greens complement each other with powerful strength. At this short time of the year, little else is needed in a painting lest it include too many things and lose its poetry. Sometimes when so much in nature is so stunning, the artist must be a harsh editor.

Winter adds dramatic cloud formations to the library of subject material for the artist to draw upon. It is as if much of the color lifts from the quieted earth to the waiting sky. Meanwhile, the landscape is reduced to the essential. With the absence of foliage, structure becomes prominent again. Tree trunks and branches reveal an expressive anatomy that is concealed at other times of the year. Winter is also the season when the strength of large shapes makes it easier for the artist to paint a solid landscape because

under snow the details of the landscape simplify themselves or disappear altogether. In addition, shadows that fall on snow can be used as a compositional tool by the artist to direct the eye of the onlooker. They can be made to tumble down an embankment or climb tenaciously up a rock, then dip and rise over the tracks in a road or sink into an icy stream bed. The artist with heightened sensitivity to the intricacies of nature will frequently use winter shadows to tell the story of the land that lies frozen underneath.

The beauty of each season is undisputable. It is the potential of the transitional landscape, between seasons, that is often overlooked. It is here that the grist for quiet, harmonious paintings waits in abundance for the artist who has unique sensibilities and an eye for the lyrical in nature.

ALONG THE SAWKILL
24 × 40 inches, pastel, 1995

Winter has its own melody. Here the unfrozen water reflects the grace of the hemlocks on one side and the leafless deciduous trees catching the light on the other. We often find stronger color in the winter sky than in other seasons.

SICKLER ROAD MEADOW
13 × 22 inches, pastel, 1998

Here is a transitional painting in which spring blossoms are gone from the apple trees and the grasses are beginning to dry, but the fruit has not yet formed. The mood, however, is strong, a quality that is often possible even when the landscape is not at any particular peak season.

Many painters and photographers are seduced by nature's parade of autumn color in September. After those ideally warm, beautiful days are over, and the leaves fall, the tripods and easels disappear as well. But paintings that are the outcome of trips into the gray woods on the cloudy, damp days in November by hearty artists with refined perception illuminate for the onlooker the stripped-down potency of nature's elegance. When skillfully executed, many transitional paintings are memorable because the vision of the painter encompasses more than obvious seasonal characteristics. It transcends the ordinary and moves to the delicate realm of mood. When this works, a masterful landscape unfolds. Where the end of one season overlaps the beginning of another, an ephemeral magic exists. Oddly enough, transitional times of the year are often overlooked: a lost opportunity to those who are always waiting for the height of each season to dust off their portable easels. Dried grasses showing through melting snow in February, or a clearing sky after a storm in November, hold the same optimism for the human spirit as the crocus in April.

Each season is enhanced by the assurance of the other three. Many times when we think of one season, we compare it with another. Seasonal content in paintings can evoke hope and the resolve to give up limited views or to end a phase in our lives with grace. Becoming more attuned to the rhythms of nature depicted in a painting can remind us to strive for ways of living that are less fragmented. That so much of nature's cycle mirrors our own lives is reason to believe that nature will endure as subject matter for all artists and that landscape painting will sustain its place in our culture, no matter what the technique or style. The poetic landscape links nature with the human awareness of that unity.

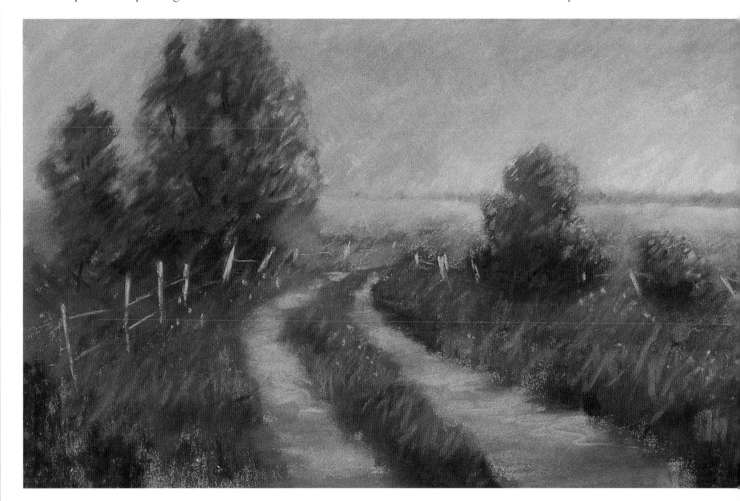

EVERGLADES PATH
8 × 19 inches, pastel, 1995

*Warmth colors the dawn in this painting even before the sun appears. It is always a privilege
to witness the first light of a new day. The time is momentary and timeless at once.*

The inevitability of seasons and tides is a theme that reflects a meaningful continuity in the lives of all people. Claude Debussy's works remind us so poignantly of his nostalgia for the sea. Handel's "Water Music" suite is still among the most popular of all his works. And Vivaldi's "The Four Seasons," although neglected along with his other work after his death, has in the twentieth century been firmly reestablished in the repertory of music.

TIME OF DAY

The most poetic times of the day for the landscape artist (and perhaps for anyone) are dawn and dusk, the beginning and the end of light. Rarely are we privileged to witness the actual moment of change in natural phenomena without a great deal of time and effort. How many of us have actually watched a flower open before our eyes, seen an animal build its home, or noticed exactly when a maple leaf changed color? Yet with uncompromised regularity, we have the daily opportunity to witness light begin to occur within just a few minutes as we retrieve the morning paper, or drive to work, or walk the dog. When the mind is quiet, watching the first light embrace the earth can be a spiritual experience, or near to it.

We associate beginnings with renewed energy, enthusiasm, anticipation, and hope. Endings have their own distinctive charm, evoking feelings of restfulness, freedom, the satisfaction of work well done, and the ephemeral melancholy that comes at the end of a day that will never return.

The beginnings and endings of many things often appear more interesting than what happens between them. Consider appetizers and desserts, necklines and hemlines, introductions and epilogues, youth and old age. But for beginnings and endings to exist, middles must as well. The middle is where necessary details take place, where studied techniques are executed, where practice and endurance have their hour, and where, for the apex to be reached, the beginning comes to an end and the end begins.

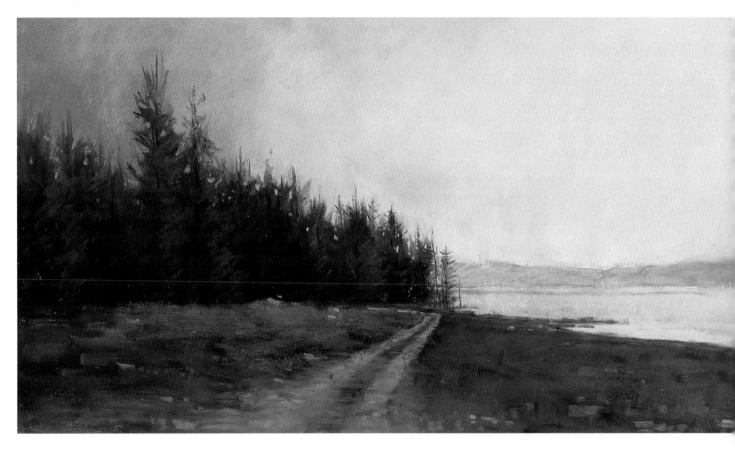

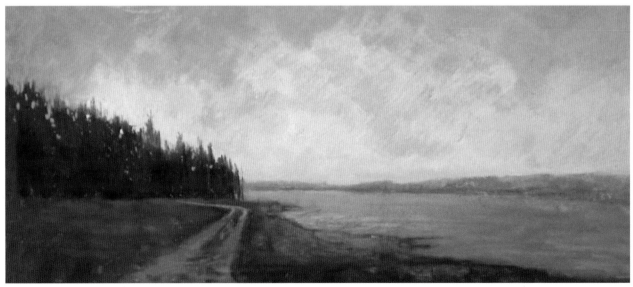

LEFT
BAY ROAD I

10 × 30 inches, pastel, 1999

A dirt road hugs this shore of Pembroke Bay in Maine before it disappears into the woodlands. Early morning burn off completes the solitary mood.

BELOW LEFT
BAY ROAD II

6 × 14 inches, pastel, 1998

BELOW
BAY ROAD III

6 × 12 inches, pastel, 1998

In other paintings of the same subject, the mood becomes more active due to the quality of light in the sky, which colors the water and the path.

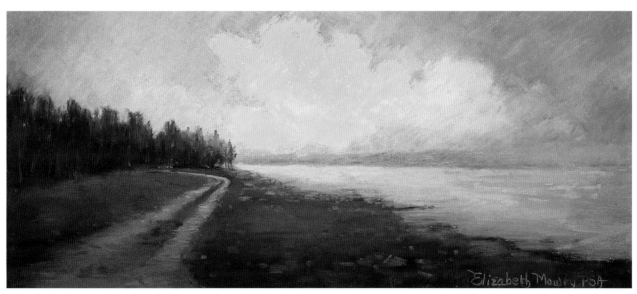

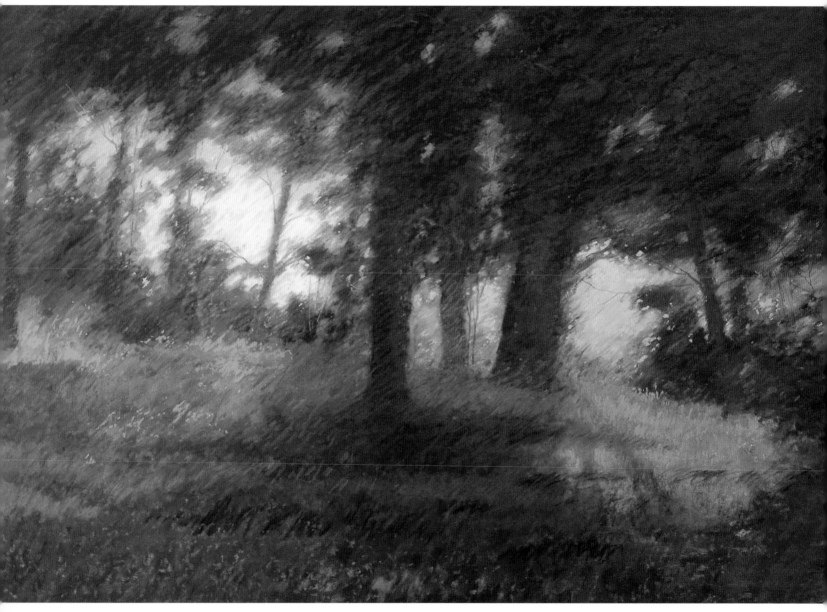

MARCOTT MORNING
24 × 36 inches, pastel, 1995

In the early morning, backlit trees throw shadows toward the foreground of a landscape. This painting's focus is on the rosy morning light as it creeps over a hushed landscape. Only the light was important to me. All other color is subdued so the idea will not be diluted.

Each day, color, along with light, appears first in the sky and minute by long minute is claimed more and more by the landscape. Because dictionaries tend to make little differentiation between dawn, sunrise, and early morning, an artist, as the scholar of light, must make some visual distinctions. Dawn might be considered that brief time before sunrise when light is already in the sky but before the source of the light (the sun) is visible. At sunrise, or daybreak, the darkness of night is broken by bits of early sun that, in turn, cause the first sweeping shadows of the day. In the early morning, a row of backlit trees will throw fanlike shadows forward across meadow grasses. Dew still glistens on summer weeds that hold gossamer webs wrought since the previous day's end. Moisture freshens the wildflowers into renewed composure. Blue-gray mists lift from still mountain lakes that hold unbroken reflections of shoreline rocks and occasionally a lone early canoe before the first morning breezes send ripples that erase the reflections away and compose a different landscape. Birds and small animals are active as grasses softly whisper, and the rose glow of early dawn colors a cloud-strewn sky and then fades before the hour. These are privileged moments for the artist and the poet.

Throughout the landscape, when the midday sun is overhead shadows dwindle to nothingness before they begin to grow again. Strong light bleaches out color.

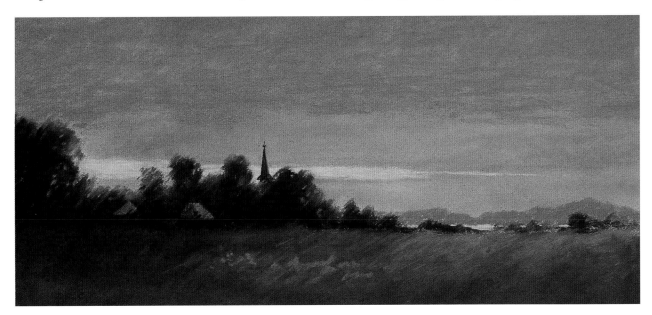

VALEUR AT TWILIGHT
7 × 14 inches, pastel, 1995

A hint of the architecture of an old mansion along the Hudson River rises from the trees in the dark painting. The possibility exists for the viewer to subconsciously envision some scenario relative to his or her own life experience when a specific place is painted in a nonspecific manner.

In summer, plants wilt, flower buds open and fade, birds and babies nap, skies haze over, and only the doves and katydids call. In winter, midday becomes white monotony until the shadows re-embroider their blue and purple designs again. From an artist's standpoint, when shadows disappear during the middle of the day, objects flatten because planes are less obvious, making topography more difficult to read and, most of the time, less interesting to paint.

In the evening, the last moments of late light succumb to the spreading shadows as the sun is swallowed by the horizon. Color drains off the landscape inch by inch, reclaimed finally by the sky. This is dusk when the sun is gone, but for a brief time, the sky holds out a magenta and alizarin valedictory to the day. It is when hedgerows darken as woody shrubs give up their final warm shaft of light. Quiet pervades, and after the last bird song lifts into the cooling air the frogs take up their chorus, a prelude to the soft nightlong music of peepers and cicadas. No more sunlit ripples on the pond. Night quiets, then claims the landscape, a metaphor for rest, or for welcome death. There is much symbolism in all that is poetic. Sunsets, sometimes subtle, sometimes dramatic, are memos from nature to us telling of the necessity of balance in the universe between activity and rest, between use and replenishment. Sometimes it is darkness that provides the first glimpse of holiness in our everyday lives. When light disappears, we are also faced with a melancholy reminder that we must give up our claim on the day.

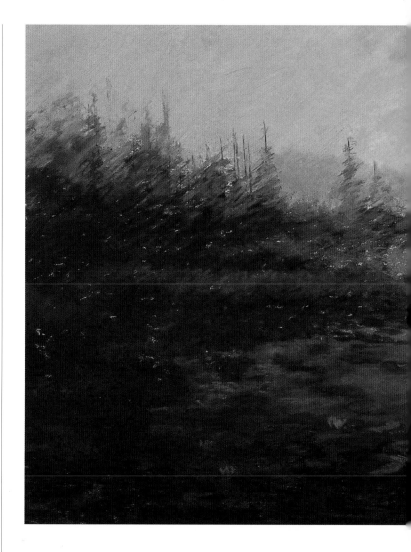

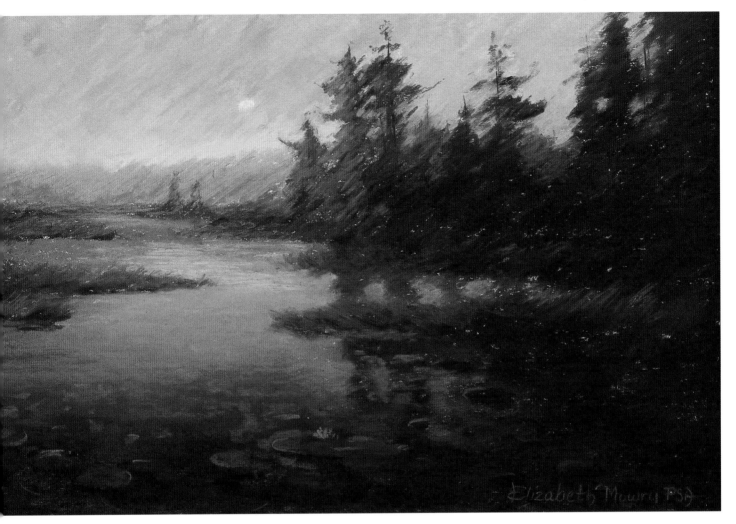

APPROACHING DUSK

10 × 23 inches, pastel, 1995

The dimming of the day is conveyed by the rosy light reflecting on this watery Adirondack bog. Color is retreating from the earth and the sun will soon disappear as night claims the landscape.

THOUGHTS ON TIME OF YEAR AND TIME OF DAY

Although I find the symbolism associated with beginning or end of day undeniably intriguing, it is probably the emotional and visual impact of the color subtleties at dawn and dusk that have most to do with why I frequently choose to depict those times of day.

As a child my life rhythms followed the light. At dawn I was awake; when the light waned, my day was over.

There is so much more to notice about a day than its place on the calendar or whether it is sunny and warm or rainy. Artists know that, for them, light effects the way everything looks. We are always romancing light. Monet's rigid schedule of waking up before dawn and retiring early is well documented by his peers and biographers, and his water lily paintings are the enduring legacy of his passion.

Inspired artists of every generation paint and sculpt explorations of seasonal themes with astounding freshness. In the center of the small village of Vail, Colorado, a delightful sculpture of free-spirited children frolicking in a fountain utilizes the beauty of nearby mountains as a background. It exudes joy, youth, playful energy, and spring. Along a small pathway not far away, the carefree movement of a girl on a swing, captured flawlessly in bronze, speaks of summer. On yet another lane, a simple setting of saplings hosts a sculpted duet of life-size stags frozen in quick departure as if the footsteps of a human intruder had just broken the silence. And, several blocks away, after crossing the town's covered bridge, one is astonished by yet another breathtaking spectacle. Bronze reeds, full-grown and bending with the wind, rise from a mountain brook with natural stones and pebbles and above them flying geese are artfully suspended. Finally, outside some shops, the racing form of a skier is pitched with perfection down an invisible mountain. The content of each of these impeccably executed sculptures was derived from, and now exists with, nature's seasons.

I remain intrigued by the patterns of light throughout each day, and by the cycle of seasons as they effect what I strive to paint. In life too, there is a season for all things. My work has claimed its own season as well. I no longer feel compelled to chase after the rainbows I was so desperate to find when I was a younger artist and more naive. Sadly I realize that when my work had far less merit, I had so much more to say about it. Now strands of harmony and inter-relatedness are weaving a design through the winter of my life more beautiful than any I could have chosen. My statement today is that there is no statement. Now the work must be my song.

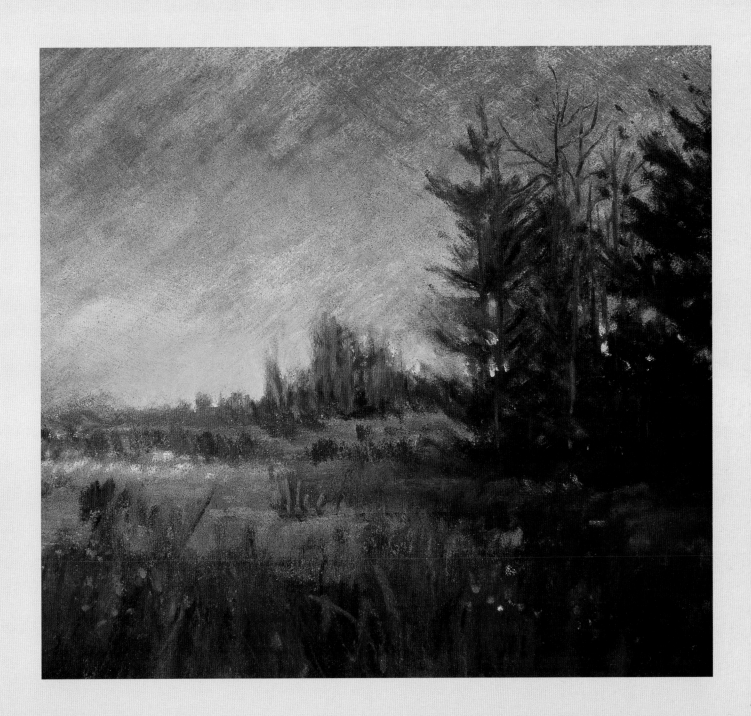

TIME OF YEAR AND TIME OF DAY

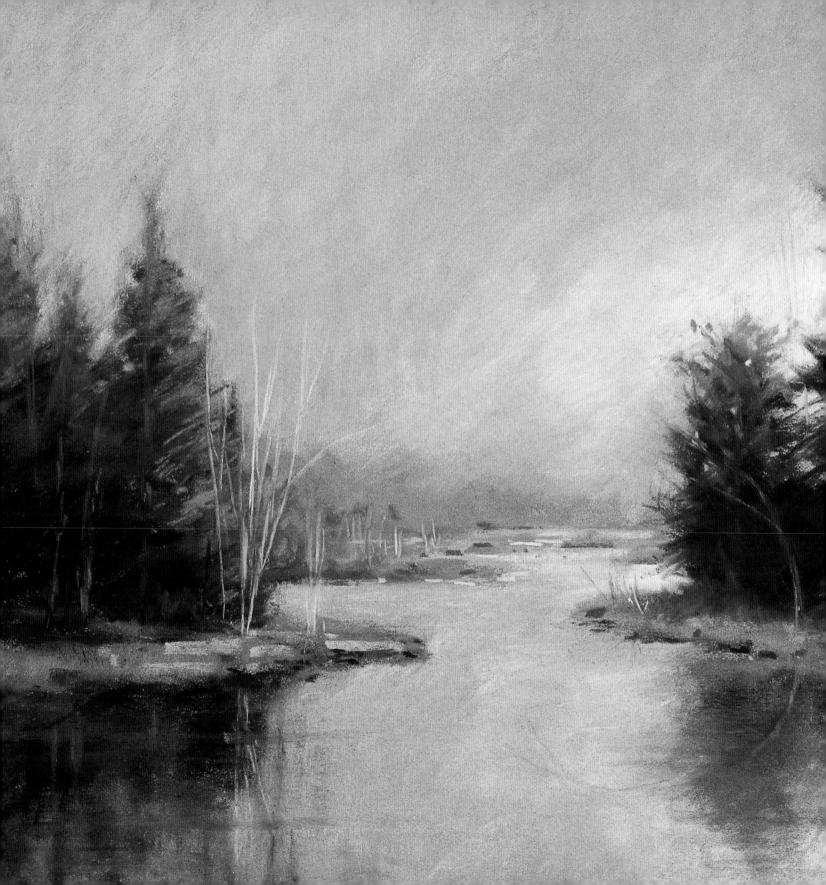

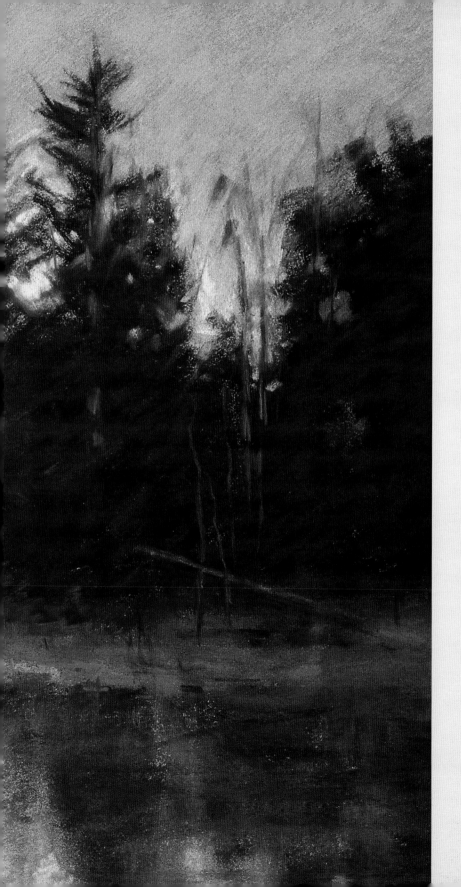

Atmosphere and Weather

"That landscape painter

who does not make his skies a very

material part of his compositions

neglects to avail himself of one

of his greatest aids."

JOHN CONSTABLE, 1921

All of our landscape is influenced by quality of light, atmosphere, and weather. Although natural events such as flooding and earthquakes, as well as development by humans, can change the environment suddenly, the shaping of nature occurs gradually over thousands of years. At any time, the earth reveals landscapes in varying stages of growth, maturity, and decline, all resulting from the actions of geology and climate on its surface.

Weather is part of our everyday world. It is predicted and recorded in our newspapers and on television programs with sophistication. We consider the weather each day as we decide what we will do, what we will wear, how we will travel, and what to pack in our picnic baskets or our luggage. Weather also determines if a landscape artist will work outdoors or inside the studio. Because weather is one of the elements of nature over which we have no control, we learn to plan, to take precautions, and to be flexible.

Cézanne commented frequently to his friends about the solitariness of landscape painting. His own confrontation with the landscape was an important aspect of his life and work. This was most certainly true of Van Gogh as well, who painted daily in the suffocating heat and the relentless mistrals that raged over the fields of southern France.

Weather puts its stamp upon our landscape, sometimes with a heavy hand. Being out and about in inclement weather can stretch our perceptions and leave us with strong and lasting impressions. Trudging through the woods and fields in the cold wind and rain is not something we want to do with regularity, but witnessing the lean of the trees from the push of the wind and the direction of the rain helps us to understand what has occurred when we view those trees after the storm. Seeing a stream rush along during a driving rain, pushing at the plants and grasses in its path as it swells, shows us firsthand why those grasses bend the way they do long after the flood waters are gone.

For an artist, weather and atmosphere play a significant role in virtually every landscape painting. Atmospheric conditions always influence the quality of light; how the artist perceives and paints the intrinsic properties of that light will determine the mood of a painting. From their biographies and letters, and not surprisingly, we learn that Sisley, Turner, Pissarro, and Constable all believed that how weather effects clouds and sky determines the mood of a landscape.

In a real-life landscape setting as well as in a landscape painting, the sky is nature's grand theater for the drama of weather. The only difference is that the former is three dimensional and the artist's surface is a challenging two-dimensional one. The sky, including all types of clouds, defines weather, and the ability of an artist to integrate what goes on in the sky with the earth beneath it determines whether or not a painting is convincing. We have all seen landscape paintings that almost work, but not quite: The parts are all well executed but they do not add up to a harmonious whole. Such efforts are examples of technique without poetry.

The best way for anyone to learn about sky and clouds is to study them firsthand over a long time. Photographs and sketches freeze movement and shapes for later reference. Although the possibilities

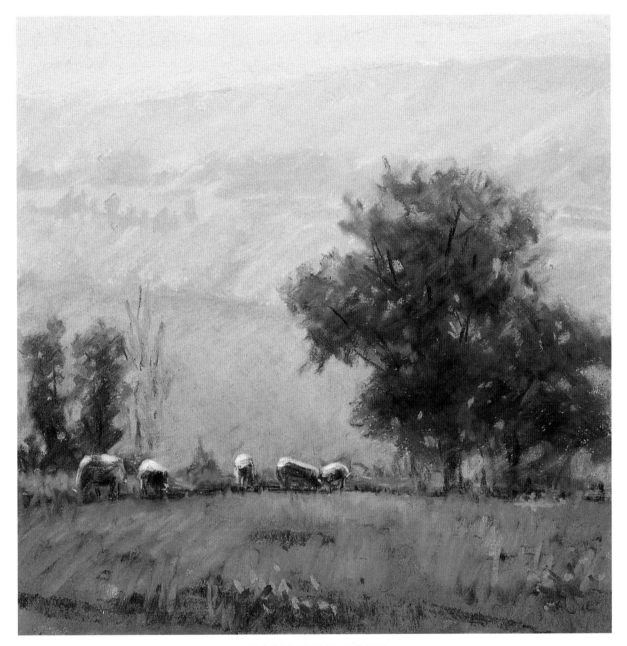

NORMANDY COWS

7 × 7 inches, pastel, 1999

A layered mist over the hilly countryside almost dismisses the background, showing how nature's atmospheric condition can place importance on the foreground of a landscape.

for the design and color of sky dramas are endless, they are usually founded in logic, so that it is helpful to all artists who are serious scholars of landscape to have references at hand. As the most masterful painters interpret the sky, they adjust reality to correspond with their personal vision. Rearranging cloud formations to hint at movement or enhancing color to suggest a particular time of day are what artists do, pushing to the edge of nature's logic but not beyond it, knowing that the sky always sets the mood and the tempo of a painting.

On a summer day, the size, shapes, and illumination of the clouds, as well as the colorations of the sky, supply information that makes the painted story of that season more complete. The float of clouds across a peaceful summer sky will evoke feelings of lightheartedness, leisure, and a sense that all is well. A turbulent, clouded sky is always dramatic. Winter clouds, tightly packed, very often hover low at the horizon. Dark storm clouds in a landscape painting will communicate a mood of physical, mental, or spiritual unrest, which can be poetic as long as the clouds symbolize a singular idea and are not paired with other dramatic elements. A simple small strip of light across a broad darkened sky at dusk above a subdued landscape will be more poetic than a depiction of midday landscape in which all the details are visible.

When the sky is the focal point of a composition, the horizon is usually low, and the landscape itself is minimal. The size of the sky draws the attention of the viewer to the narrative taking place there. If other areas of the painting compete for attention through color, size, or detail the importance of the sky diminishes. When the artist is able to creatively enhance his or her observations with luminous color and movement and still maintain the concept of wholeness a painting will frequently evoke the quiet emotion that sets it apart from the ordinary.

Many landscape paintings depict ideal weather. It makes sense for plein air painters to choose a pleasant day. It is not until we deliberately focus on weather that storm clouds, softly falling rain, or driving blizzards come to mind. Fair weather surely provides the most pleasant conditions for painting or exploring the countryside with camera and sketchbook for later reference. It has been proven that the sun has a positive psychological effect on us, and paintings of a sun-drenched landscape can arouse feelings of relaxation.

Sun creates as its counterpart, shadow. Together they constitute the most basic elements of light with which to compose a painting. Patterns of light and shadow tend to be consistent each twenty-four hours. Monet was known to have worked on several successive paintings each day, changing canvases as he observed the light change. The following day, at the same time, he could expect similar light.

Strong sunlight will cast definitive sharp-edged shadows. For a poetic landscape to emerge, the artist may have to determine where on his surface, to emphasize or de-emphasize the edges of sunlight and shadow that these light conditions provide. In warm climates close to the equator strong light is an everyday occurrence. Visiting artists may be seduced by the sharp demarcations of light and

shadow and make them the most important aspect of their paintings. Painters native to such a climate will quite often look beyond the acute edges created by light and shadow and capture the subtle nuances that remain a mystery to the casual visitor.

Painting sunlight successfully involves the creation of luminosity and a sense of warmth through the skillfully honed use of color and close attention to tonal values. In reality, a strongly sunlit countryside at mid-afternoon will appear bleached out; depicting it that way almost always results in ho-hum paintings. The same scene painted by the sensitive artist who utilizes the magical possibilities of shimmering luminosity, filtered light, and color temperature can create poetry, even in a simple composition. When nature is bathed in the warmth of a sunny day, a sense of contentment and even adventure is likely to fill the observer.

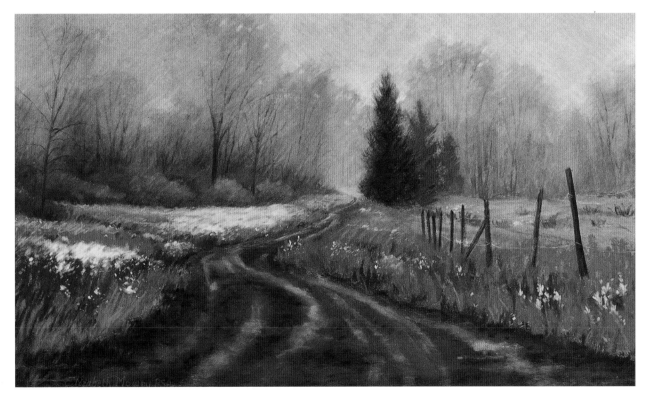

MILL DAM ROAD, SPRING
15 × 24 inches, pastel, 1997

Rain visually softens the appearance of all landscape components. In this scene, atmospheric perspective diminishes the contrast throughout the middle ground and even more in the background. Soft edges and similar color values convey the atmospheric quality of moisture-laden morning.

Rain softens the edges of all landscape components. The effects of atmospheric perspective lessen value differences, and contrasts become more subtle. A somber harmony attaches itself to all of nature. Distant mountains and trees subtly layer the backgrounds, with only barely discernible variations. City or village scenes sometimes become even more beautiful as the rain softens all man-made elements. Angles of buildings soften; lights become diffused; the ordinary puddle can add quiet excitement depending upon what it reflects, and a tree or patch of grass in the foreground can take on the vivid color that rain enhances.

Descriptions of weather in the classic English novels by the Brontë sisters and Thomas Hardy link rain to feelings of brooding melancholy and loneliness. Movie scripts still pair stormy weather with dramatic music to signal or accompany dismal circumstances on screen. Depending on the viewer's

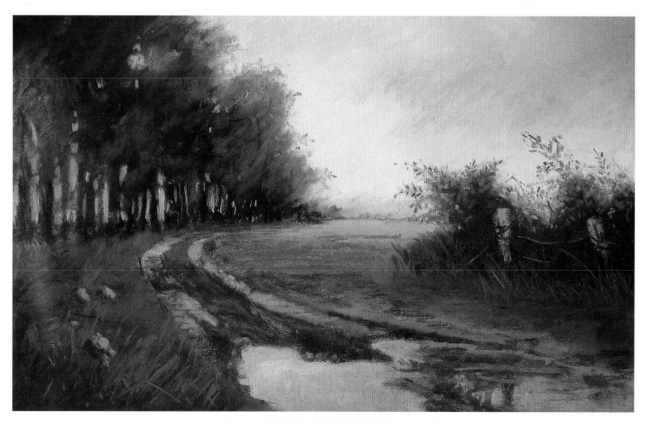

AFTER THE RAIN
5 × 7 inches, pastel, 1996

One of the reasons I do much of my painting in the studio is because I am attracted to weather that isn't beneficial to my health or friendly to my art materials. Here I was attracted to the still reflections of a clearing sky in the puddle and the wet road that connected the two.

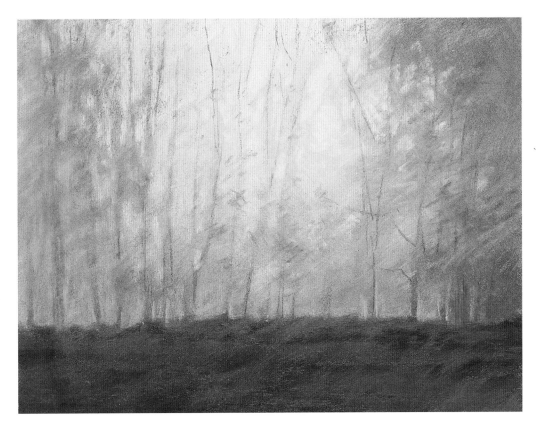

The worn-down stone wall bordering fields near my home stretches across this small soft-edged study of light, which is about to break through an early morning fog.

previous experiences, rain might symbolize isolation, dreary entrapment, or monotonous routine. Paintings can call up less than ideal emotion and be poetic. When we go to the core of any emotion, we find beauty. Within the depth of isolation or sadness is a purity of truth that is poetic. When an artist's brush can touch that truth in its movement from paint to canvas, even hopelessness and monotony become dignified and beautiful.

In the painted landscape, rain need not always suggest gloom. While what is pictured may be wet, bitterly damp, and cold, the observer is usually comfortable indoors. Also, rain may be associated with nurturing and nature's cycle of growth and continuance. In fact, one of the reasons we may feel more in harmony with nature today may be because modern advances have given us fewer reasons to be fearful of it.

Fog adds a sense of mystery to the landscape, making places we know well strangely eerie. We are frequently surprised by what happens when some part of a familiar view is no longer visible; our eyes and our minds are accustomed to absorbing the whole, and we take that wholeness for granted. Fog has an unnerving way of distributing itself in shifting layers. It can be particularly fascinating to watch the lifting and settling movement of fog as it dissipates in one area and then forms again in another.

Artists who know the properties of fog well will be most skilled at using its mysterious qualities to direct the eye to a focal point in a painting. Fog can also capture the deep intrigue we associate with coastal areas and islands. The moors in England, the highlands of Scotland, and the great expanses of stone under Irish skies can probably best be painted by those who have lived in such places long enough to watch daily how the fog choreographs its stealthy dance over those uniquely beautiful landscapes. When strangers aggressively force attempts at poetry in words or paint without a deep feeling for place, they mock a sacrament.

Mists are different than fog. They embrace the land more consistently and with a totality that most people understand. Mist is indeed one of the greatest perpetrators of mood. It can lend a special tonality to a countryside that is often misty, such as Normandy. The effect can change from dramatic to slight within hours, but its characteristics are gradual, even hardly noticeable unless one is attentive. (To understand this interesting natural phenomenon visually, one might take a camera outdoors very early on a misty or hazy morning and photograph a path or street every fifteen minutes for two hours. The eight photographs placed side by side will tell the visual story of gradual atmospheric change.) Many of the paintings of Corot and those of Monet from the Normandy coast are exquisite examples of tonal quality. Value and color integrate in such a way as to set the mood for the entire painting with such quiet force that the mood dominates the work, and beautifully so. These paintings are poems, and powerful poems at that.

Artists handle mist as well as haze differently than fog, because here there is consistent progression of increasing subtlety from foreground to background. The foreground can be quite distinct, with detail and vivid color, but these qualities progressively, and sometimes rapidly, diminish in the middle ground and background. An early morning mist can drain intensity from the landscape to such an extent that it seems as though we are looking through a gauze filter. Details disappear everywhere except in the closest foreground. Still, subtle washes of beautiful color can convincingly exist in a background of a misty painting without becoming gray and dead. A thorough knowledge of color properties, particularly complementary color neutrals, is essential to the artist attracted to this type of subject.

Mist can be used powerfully in a composition to diminish attention to everything but the focal point. Lines and outlines can be reduced to the barely significant. The eye will then glide over the painting, searching for an area of definition. Only after they take in the meaning of the relatively more defined focal point, do the eye and the mind return to the rest of the painting for additional meaning, understanding, or mood. The impact of such a skillfully orchestrated painting is timeless and memorable.

Painters who thoroughly understand the natural phenomenon of good weather are best able to make the transition to other weather conditions. Lacking this knowledge or the skills necessary to express it might be why some interpretations of weather in paintings are either weak and indecisive

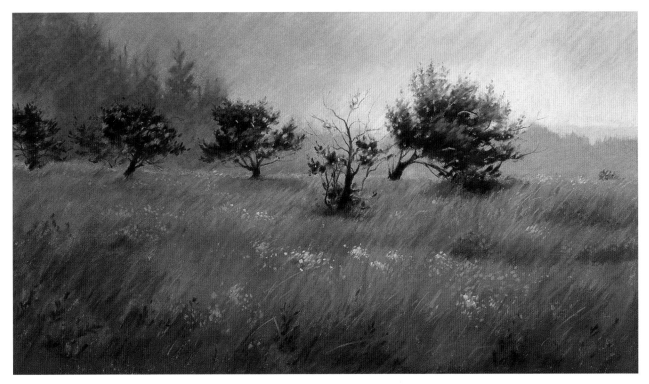

REMAINS OF AN ORCHARD
11 × 19 inches, pastel, 1993

*Soon after beginning this painting, I found that the value and color began to integrate in
such a way as to set the tone with such quiet force that "mood" began to dominate the work.
The tree formations would hardly be noticeable on a sunny day, but here a Maine morning
mist provides a melancholy background for the graceful shapes.*

or too garishly blatant to evoke emotion. It is
helpful to first establish the framework of a misty
painting with a clear artistic vision and then loosen
or soften edges, as opposed to vaguely working with
the concept of softness and merely hoping that a
plan will develop.

A hint of the sun or moon hidden by a mist or
haze will provide a ghostly source of illumination.
Here again, mastery of reserve and understatement
is the key that separates the skilled from the amateur.

In winter, the landscape is reduced to what is
essential. As the snow falls, more and more detail is
eliminated, thus simplifying the landscape. Structure
becomes prominent and the form of barns and
fences, buildings and bridges becomes a significant
compositional element. Because of the way snow
falls, it softens all structural horizontal lines. On a
sunny day, contrast will be the most important con-
sideration in a winter landscape as shadow patterns
assume importance in the design. They help the

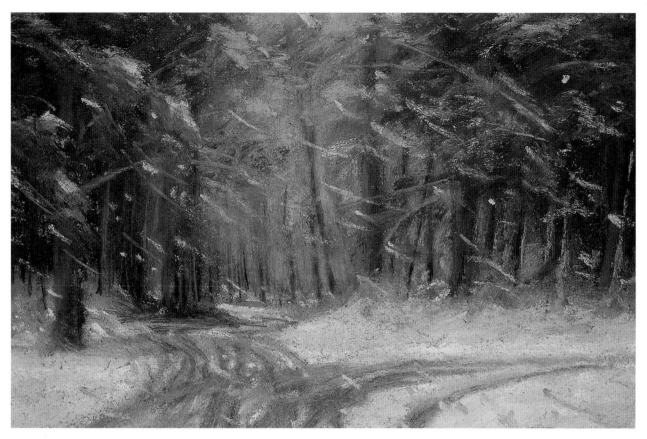

MARCOTT CORNER
6 × 8 inches, pastel, 1995

Falling snow has a way of filling the space between the eye and all that it surveys
with quiet.

artist describe the contour of the snow-covered land by dipping and rising over tractor paths, stretching evenly across ice, or reaching out from the base of tree trunks to embroider intricate patterns over gently undulating fields.

Falling snow has a way of filling the space between the eye and all that it surveys so that value contrasts between light and dark diminish and yet incredible richness remains. The squalls of swirling, eddying flakes can only be hinted at in the winter painting and even then the brush must tread lightly onto the canvas; the line between the evocatively believable and the clumsily bizarre is a tightrope for an artist trying to portray snow while it is still falling. Such landscapes, despite the movement of the falling snow, are conversely quiet with the heightened sense of silence, because unlike rain and sleet, snowfall is soundless. Bird calls stop, all sound is muffled, and

human and animal activity is stilled for a time. The mood is of solemn intensity. Dark, narrow streams are quiet, too, while the contours of pale amethyst mountains get lost in gray sky. Snow symbolizes finality, acceptance, and peace, paired with the optimism of a fresh beginning.

Drought is a best portrayed by using color temperature to simulate the lack of moisture in the soil and vegetation. Sun-baked earth reds, browns, and yellows convey the warmth typical of dried grasses and arid soil.

Springtime flooding can be painted in such a way that the artist designs the spread of water over the land to enhance the composition. When expected seasonal occurrences are portrayed instead of the high drama and threat of disaster, paintings depicting flooding can be quietly poetic.

Wind is a topic that should be addressed more often by landscape painters. Although painting is visual art and wind itself is invisible, the effects of wind add dynamic narrative to a landscape painting. Bending gnarly shrubs and leaning trees and fence posts show the forces of weather after the fact. Everyone can relate to a few final flowers bobbing wildly as their last petals scatter into fields of wind-blown grasses at the end of summer. While snow is noiseless, wind is not. It howls and moans through the bare trees, sending dry leaves whirling across the fields. An army of racing clouds painted across a sky changes the tense from past to present.

In short, no matter what weather conditions exist in a painting, the most memorable poetic landscapes have a quality of light, mood, and tonality that is more important than anything specific.

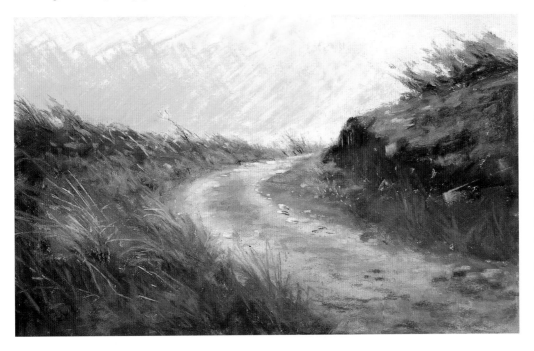

SCOTTISH ROAD
5 × 8 inches, pastel, 1995

This simple composition depicting an old military road now used by hikers utilizes color temperature and a luminous quality of light to convey mood. The dialogue between wind and grasses adds to the narrative.

THOUGHTS ON ATMOSPHERE AND WEATHER

Fair-weather painting at a picturesque location, picnic basket at the base of my easel, no time schedule . . . an artist's dream. Certainly it is uplifting to feel the warmth of the sun on my back and dry grass at my feet as butterflies draw nectar from the flowers and bird songs fill the air. The sunlight, in the dialogue it creates with the shadows, shows me the contours of the landscape that I position in my sketches.

The demands of real life paint another scenario, however, frequently very different than the dream. It is here that flexibility, a sense of adventure, and an unwavering determination become as important as color theory and perspective. Sometimes we must seize the moment or lose it forever.

During the worst of wind or rain or snow storms, the decision to work indoors is an easy one. When we venture out on cloudy days, without the direction of sunlight, nature provides little more than form. At those times, I have to call on more from within myself to shape the color and mood of my painting. Even as a young painter, I learned that when the information simply was not there for me to duplicate, I relied more on my own visual memories of pink or yellow skies and lavender fields and sun-warmed paths. I take risks. It has been on the gray and cloudy days that I have been most challenged, and, accepting the challenge, most rewarded.

Some time ago, when painting with some students in Monet's gardens at Giverny, the exquisite Normandy mist hung onto the landscape well into the morning. I was ecstatic: It was such a blessing that this would occur while we were there. Familiar with the mist that appears in the works of Monet and Corot and others, I felt enveloped by new understanding of what this special light was all about. One person in the group, however, complained of not being able to see clearly all the vivid bright colors in the flowers. She was noticeably agitated and distressed as she waited for the mist to burn off. What could I possibly say? Stunned, I said nothing.

We cannot "see" for others. There is a time and a season for all things, and it is also different for all of us. Life has a way of presenting us with whatever we are ready for and all we have to do is be open to the possibilities.

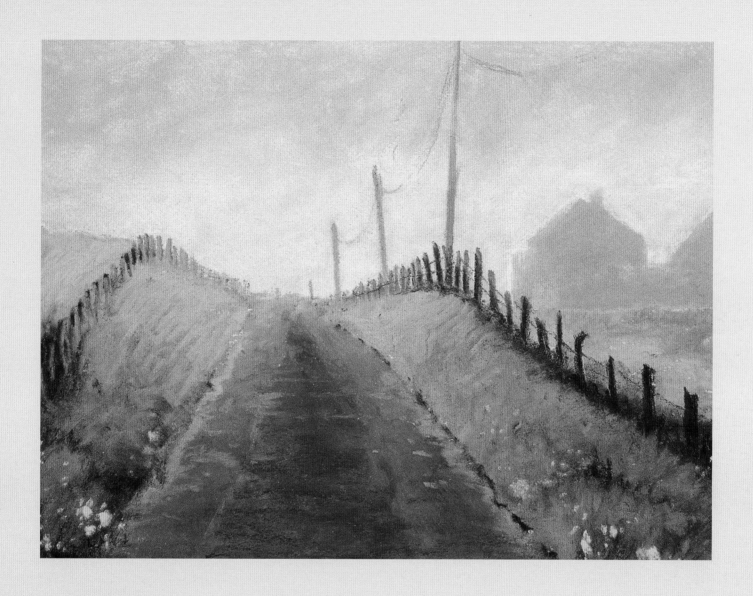

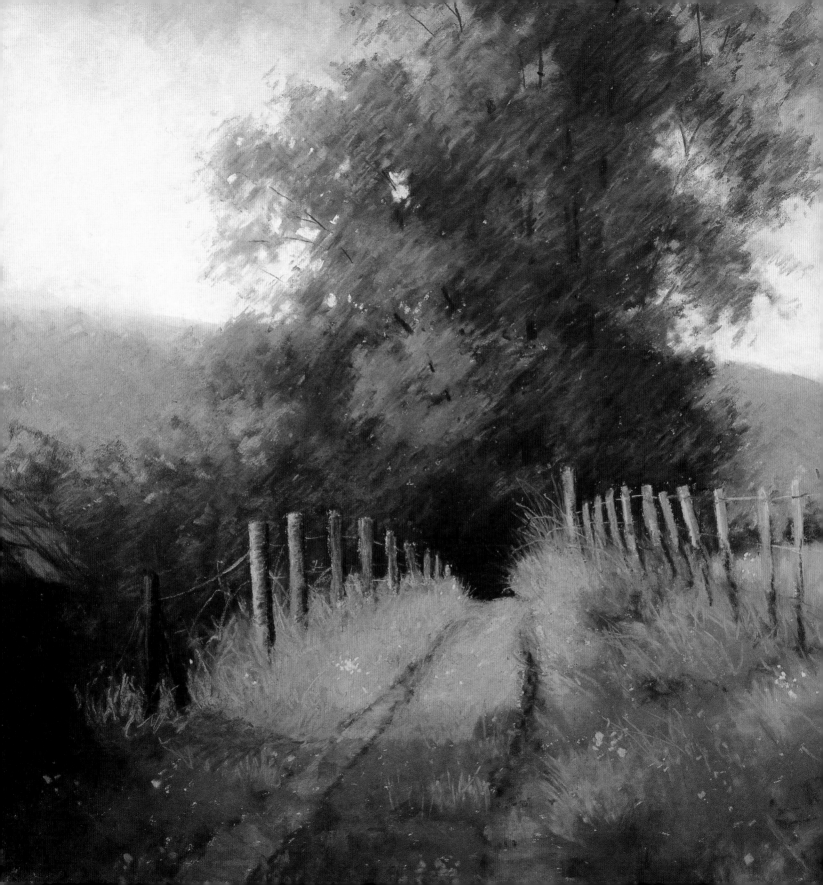

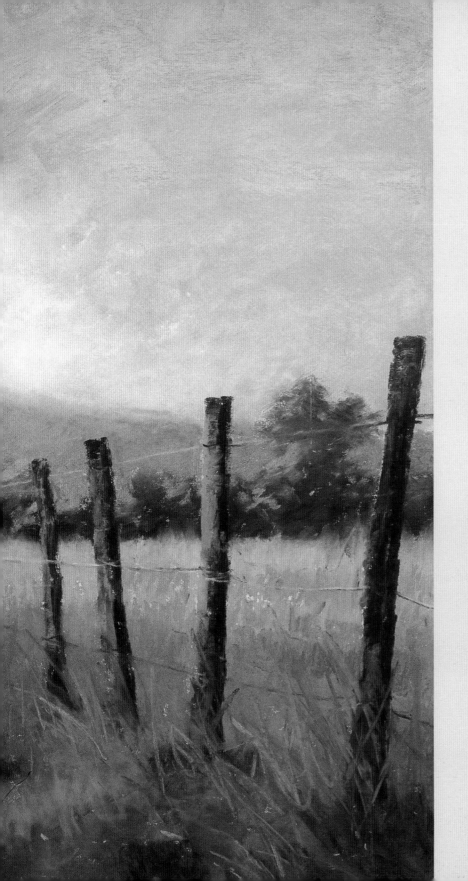

Leading and Letting Go

"The artist as a poet will have seen

more than the mere matter of fact,

but no more than is there

and that another may see if it is

pointed out to him."

ASHER DURAND

Aristotle is said to have pointed out that the capacity for making metaphors is the mark of a superior poet. In art as in literature, the metaphor fuses object with idea or idea with image. Psychologists use pictures to access emotion, and today individuals are learning that visualization is a powerful tool. The poet, whether author or artist, tends to see a larger constellation of harmony in unrelated bits of life and nature and is able to fit those pieces together into a mosaic of words or brush strokes that is more intense than straightforward prose or, in the case of a painting, a painstakingly faithful rendering of a scene.

A road or pathway can be a metaphor for one's journey through life experiences and through space and time. Its existence defines itself, showing us that others have traveled before us. The path represents a way to move more easily on to another place, thus it's an invitation from nature simply because of what it is.

In a painted landscape, roads or pathways are vehicles that suggest to some viewers a course taken or a line of movement in their lives. A road also facilitates the viewer's direct involvement in the painting by leading him into the scene more quickly than if it did not exist.

A small overgrown path is likely to suggest that this is the observer's private route—his and the artist's before him. A wider path or a marked trail hints of more frequent travelers to the special place. It might even evoke a bonding with all those who have also been there, but who have now gone on ahead or journeyed back.

Roads and paths drawn or painted onto a two-dimensional surface follow the rules of perspective and diminish in size with distance, often disappearing somewhere in the middle ground of a painting. If a road curves provocatively behind a hedge or group

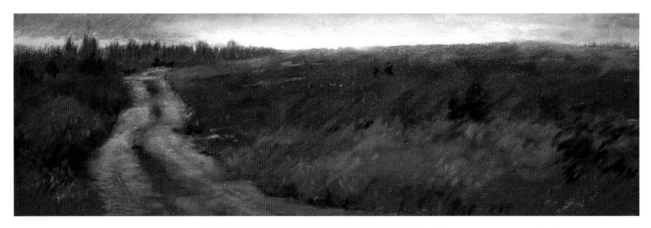

BLUEBERRY BARRENS, MAINE #1
5 × 15 inches, pastel, 1994

At the end of summer, the blueberry barrens are desolate. Earlier in the season these fields would have been filled with pickers, crates, and vehicles for transportation. In this painting, the eye follows the track through the lonely expanse of acres resting under the waning light.

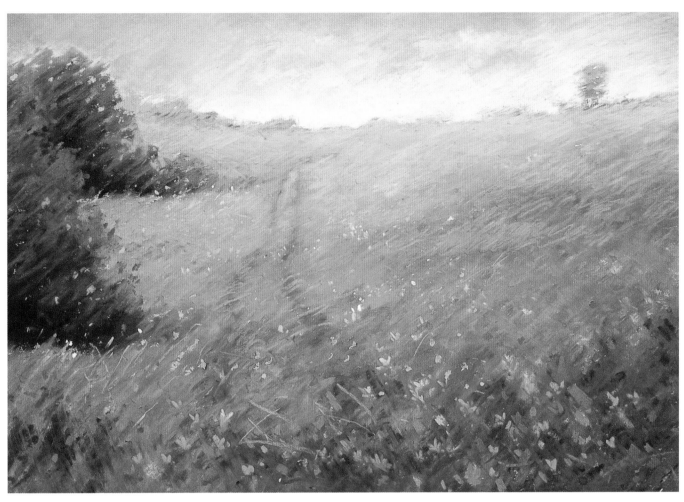

POET'S WALK
9 × 13 inches, pastel, 1997

With it's views of the Hudson River, a recently created trail welcomes the traveler with thoughtfully placed benches, wooden bridges across the ravines, and gazebos that encourage one to linger in the landscape much the same as the painted path welcomes the beholder into a painting. Here a tractor path through wildflowers and grasses disappears at the crest of a hill that overlooks the river.

of trees, or a structure such as a barn, or if it meanders over a hill and is no longer visible, the observer will feel gently abandoned. This is an artist's way to set the stage for inviting the viewer to become an active participant in the painting. At this point, the place pictured no longer belongs to the artist, but is instead a gift to the beholder to use as he or she will, for recall, for hope, or just to be with the moment. Hence, the viewer is encouraged to enjoy the pleasures of imagination based on his own experiences so his connection with place becomes personal and meaningful. For the artist to leave a viewer in a painting rather than showing the way out is not only appropriate, but desirable. In that way, the viewer can linger in the magical space for as long as he or she wishes.

Many people are intrigued by the idea of roads and pathways. The words are weighted with symbolism: In elementary school we become acquainted with Robert Frost's "road not taken," in early adulthood we search through the pages of M. Scott Peck's *The Road Less Traveled,* and later in life we explore life's transitions in such books as Gail Sheehy's *New Passages.* That a landscape artist can lead the observer to a particular space in a painting through a well-conceived composition plays a dominant role in the success of poetic landscape, where personal connection is an unspoken priority.

Most people do not even realize they are being led into a landscape painting by a road or pathway. Even if they did, it would not be uncomfortable. From the time we are children, we instinctively reach for the hand of someone older to be guided across a street to the playground. It follows quite naturally that even as adults we may find it more relaxing to enjoy the view than to drive the vehicle and find the way. As we view a painting in a museum or a gallery, our understanding may be enhanced by the notations of a discerning curator. If a road or pathway within the work itself provides additional facility to the eye, all the better.

The road or pathway in a poetic landscape can also represent possibilities. It occasionally encourages one to get off the main highway to explore the unknown, to backtrack and take time for reflection, to re-evaluate. Depending upon our needs, it can be a symbol encouraging us to plod on, an affirmation to change direction, or a gentle caution to get back on track.

The idea of passage from one space to another by body or mind is a captivating topic in all of the arts. Most often, visitors to museums and galleries are strolling from painting to painting so that a picture depicting a path or a road requires very little transition for the mind to move right into it. Free associations, conscious and subconscious, occur on all levels by those who linger before the painted pathways of George Inness, Jean-Baptiste-Camille Corot, or Winslow Homer, or the poetically photographed landscapes of Eugene Cuvelier.

An open gate extends yet a second invitation to the passerby in a natural landscape as well as to the observer of a landscape painting. The same straightforward welcome is clearly felt at the sight of an open doorway, an arched trellis in a garden, an opening in a stone wall, or any other simple or elaborate symbol of ceremony placed with care to alert the onlooker that something special is waiting beyond to be shared.

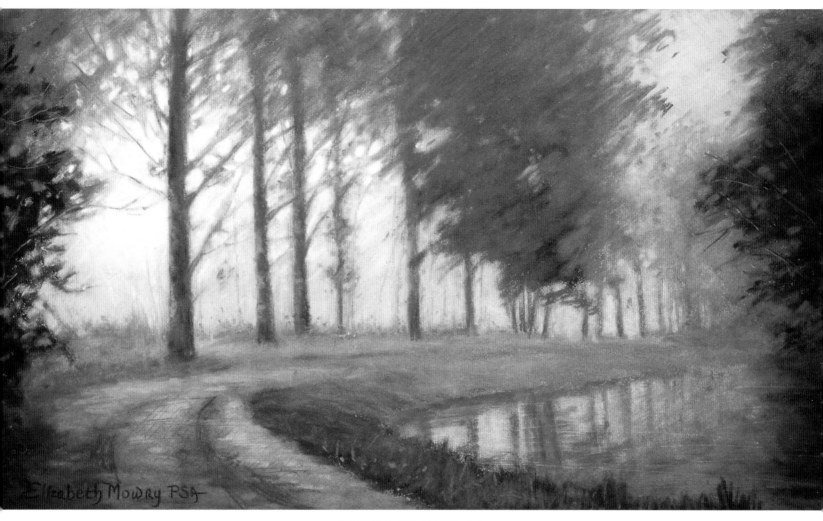

ALONG THE EPTE #6

9 × 16 inches, pastel, 1996

I felt blessed to witness the first morning light as I walked along this beautiful French river.

Although I was alone, the road suggests room for two people walking side by side.

ADIRONDACK DUSK II

10 × 23 inches,
pastel, 1995

Water paths through wetlands, as well as rivers or streams, penetrate the painted landscape. Here at dusk, the day's last light reflects on still water. While painting, I omitted much of the detail so as not to compromise the idea of the painting, which was the rosy pattern of light in the water and the sky.

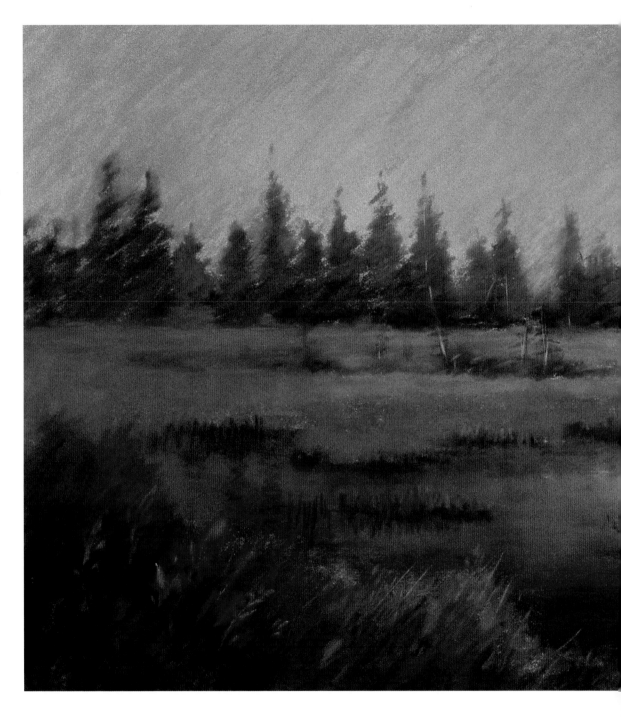

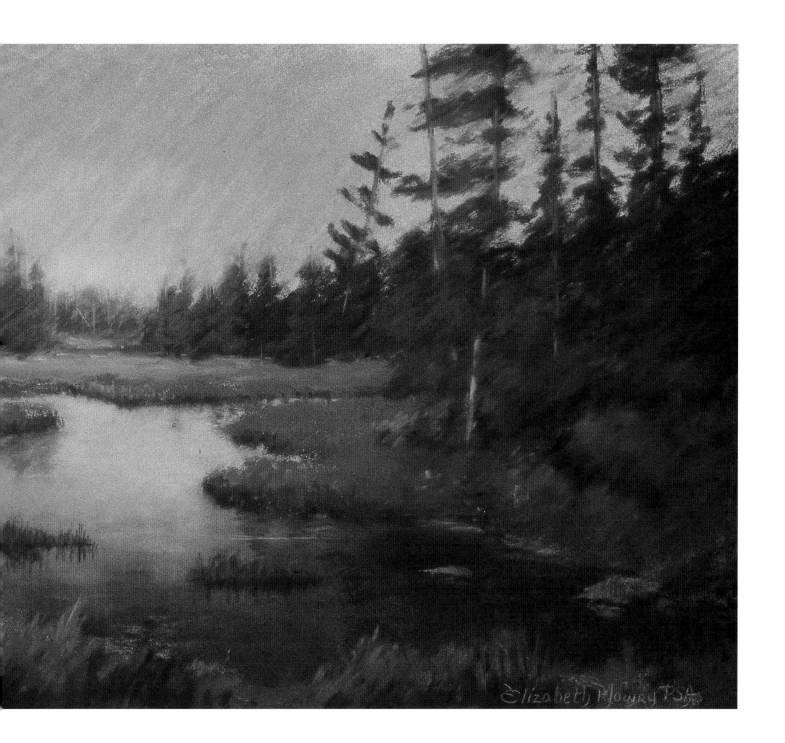

Just as roads and pathways call out and welcome the traveler, when their entrances are blocked by such things as closed gates, cable barriers, or even fallen trees they send a conflicting message to the onlooker. The road or path constitutes an invitation: A barrier implies that one should stay out. This presents more of an affront than if no path or road existed in the landscape at all and unmistakably indicates that one is not welcome. In a painting, these contradictions stop the eye from proceeding as well. The opposing messages cause one to feel stuck in an undesirable space.

When a composition includes water, such as a pond or stream or river, the eye normally hesitates at the water's edge. Here a bridge serves the same purpose as a road through dry terrain. It may be as simple as a few stepping-stones or a plank of wood over a shallow stream or as sophisticated as a glimmering expanse of steel over a meandering river. In either case, it provides the mind access to what lies beyond the water, then on to another part of the landscape. Bridges, whether over a swiftly swirling stream or an uninteresting dried-out ditch, quite clearly convey "I will help you from here to there," and in our culture "there" seems always to be imagined as "better" than "here." We seem to believe, or need to believe, that the grass is always brighter, sunnier, and greener "over there."

Coinciding with a time-honored yearning to chart new courses, explore and tame new territory, or conquer the wild and unattainable, it is human nature to be attracted to new beginnings, especially when there is some dissatisfaction with where we find ourselves now. The idea of getting through one phase in our life and beginning over is aptly symbolized in a painting when the foreground is bridged by a path or a roadway to a distant part of the landscape. Everything in the distance appears less distinct and a bit more dreamlike and malleable, allowing us to make subtle free associations as to what lies there based on our individual needs.

"The most perfect guide is nature" were the words on a plaque in the studio of Michelangelo's teacher, Ghirlandaio. Guidance by the more experienced has been a tradition from the beginning of time. Masters of philosophy, counselors, teachers, and conductors of symphonies guide people toward better understanding. The poetic landscape, too, can hold a place of esteem within that list because it respectfully honors man's communion with nature and puts man in touch with his own feelings.

Most people today work to earn a living, and sometimes the workplace, especially the urban workplace, can be a heap of smoldering tensions ready to ignite. When we daydream of "vacation" we usually think of being somewhere else, away from our customary routines. We visualize travel to another place to relax, wind down, slow our pace, or simply use our energy in a different way. Travel is synonymous with roadways, airways, railways, or simply pathways, and all of these make getting from one place to another easier and less time-consuming in an era

when time is at a premium. We are grateful for paths, carriage roads, and marked trails that welcome us to share what others have found to be spectacular, or even just quietly harmonious. Paths, roadways, and waterways allow us to see the best views in the shortest time, without getting mired down along the way. Of course, there will always be occasions when it will be important to search out and find our own way, but how often do we feel compelled to bushwhack another Appalachian Trail?

Roads, pathways, bridges, and doorways link us to the positive optimism of something fresh and new, not sullied by the reality of now. In a harried world where people are obsessed with accumulating more things, a poetic landscape's pathway or bridge can stretch metaphorically toward a calmer, less stressful pace for everyday living. Thus in a poetic landscape, an important painted dialogue passes from artist . . . to painting . . . to place . . . to viewer . . . and, through a mutual connection with that place, back to the artist.

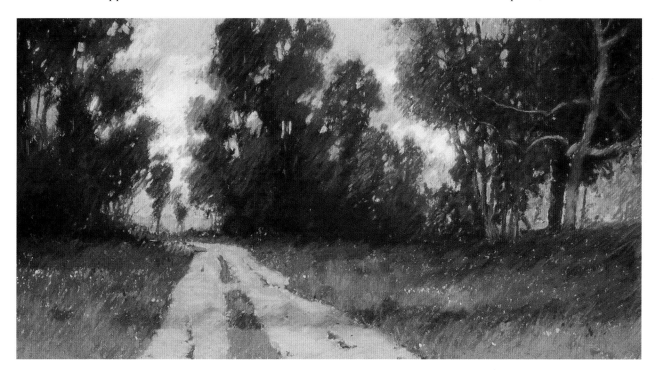

VIOLET GROVE
9 × 16 inches, pastel, 1995

The road in this painting is straightforward and takes the onlooker directly into the center of the painting where violets emerge from the shadows.

THOUGHTS ON LEADING AND LETTING GO

Poets are involved in one specialized area of writing. From an immense vocabulary, they arrange words to concisely express an idea. On one end of the spectrum lie all the possibilities of language; on the other, the silence of the impression, unshared and unexpressed. Somewhere in between lies a poem. In delicate comparison, artists within the genre of landscape painting are also concerned with conveying an idea, not just recording information as it exists. Artists use a myriad of techniques and skills to draw upon, and nature comprises the landscape artist's language of possibilities. Somewhere between all the choices that exist for the artist on one hand, and the silence of a blank canvas on the other, a painted scene can become charged with quiet significance and evolve as poetic landscape. The creator of such a painting emerges a poet, the visual author of a privileged moment.

As a landscape painter, I find that roads and pathways have begun to appear in much of my work. Having lived near a park as a child, I have been intrigued with pathways ever since I can recall, paths edged with fern, and trillium that led to berry patches and shady violet groves, and out again into fields of sunlit Queen Anne's lace. Later more challenging paths farther from home led me up steep mountains to breathtaking vistas that held dreams of much yet to be seen and experienced and then down through valleys to quiet picnic places along rocky streams and daisy-strewn meadows. For everyone, the pull of a pathway seduces us onward, just a while longer, or just beyond the next bend.

The narrow path makes us feel that we are among a privileged few. We must look downward, watching our footing, and are rewarded with the closeup intimacy of nature . . . the rocks, the mountain laurel, the lady slipper, the mosses, the scent of pine needles. The wider paths and carriage trails are less demanding; traveling on them, we look ahead, taking in a larger context, feeling a camaraderie with our companions now and all those we meet along the way.

And so it is still. I have adopted the path as my own metaphor for life, for moving forward, chapter by chapter. Now the paths are along less strenuous rail trails and through open meadows close to home. My walks are a daily ritual but not at all uninteresting because my visual appreciation for minute daily change has matured and compensates for waning strength.

By using a path or roadway as an integral element in my work, the presence of an invitation to the viewer is purposeful and direct. He or she can then (just as when walking through a field or wooded area) take the path, or not.

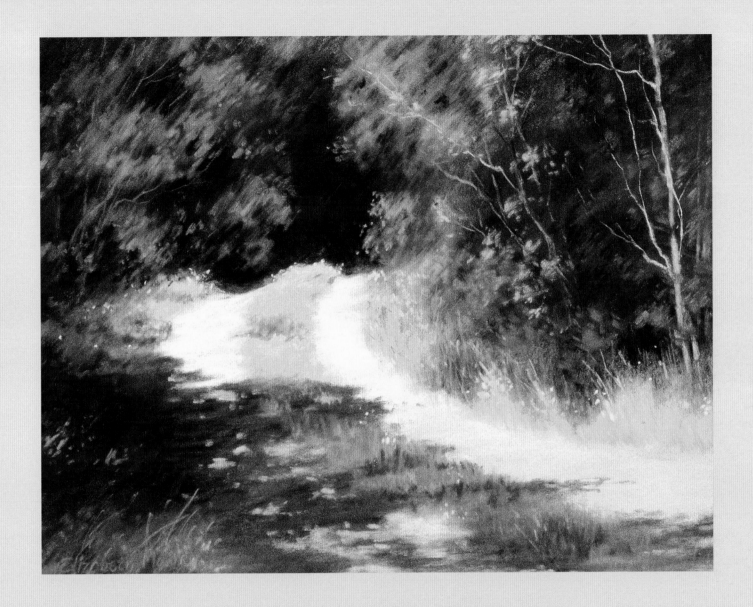

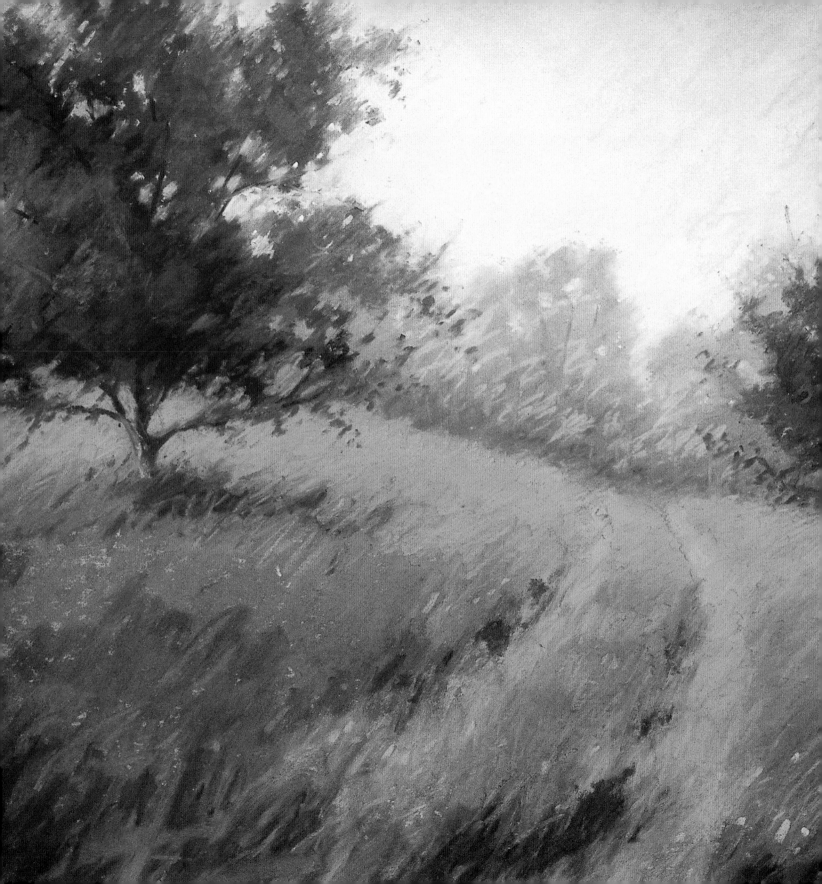

Recognition

"The true purpose of the painter is simply to reproduce in other minds the impression which a scene has made on him."

GEORGE INNESS

"Nature matters to people. Big trees and small trees, glistening water, chirping birds, budding bushes, colorful flowers . . . these are important ingredients in a good life."

THE BIOPHILIA HYPOTHESIS

In the poetic landscape, "recognizable" refers to a sense of place rather than specificity of place. People with vastly different life experiences respond in a positive manner to common landscape elements that are familiar. When, through recognition, a sense of place is paired with the poetic in painting it bridges all differences in politics, economics, and social status. It speaks to the privileged and the poor, the faltering school child and the elderly scholar, the disabled and the athlete.

In *A Place to Begin,* Hal Borland reminds us that we all go back to places we know and love "to see and hear and feel the certainties that are beyond human reach." Some of those certainties that come to mind are symbolized by the tides and the seasons. When a crisis must be put in perspective, who can forget the comfort and groundedness of walking barefoot on warm, wet sand as it welcomes the waves rolling in from the sea? And when transitions in our lives disrupt predictable patterns, haven't we

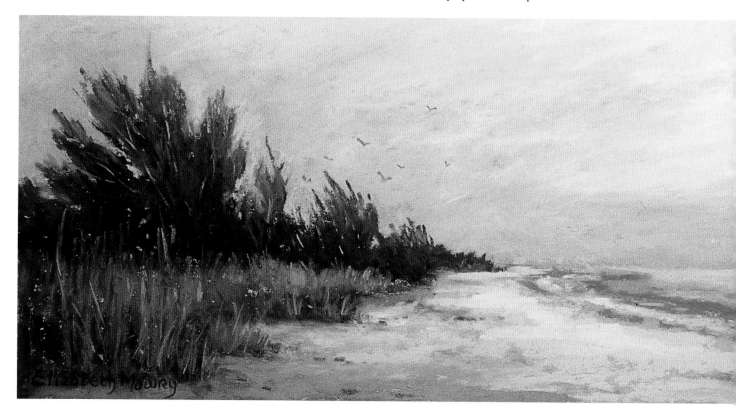

SANIBEL SOLITAIRE
5 × 15 inches, pastel, 1997

Poetic landscape embraces at its subject the common as opposed to the uncommon. The sea will speak to many of infinity, or freedom, or power. In this little painting, the indistinct boats out in the water pose no threat to quiet contemplation of anyone walking alone on the beach.

all made the pilgrimage back to the familiar, whether it be the red and yellow foliage of autumn or the marshes that stretch to a barely discernable horizon as we look for resolutions that hide beyond the realm of words?

Wordsworth defined poetry as "emotion recollected in tranquility." One reason that poetic landscape painting is appealing is that it embraces the common, not the uncommon. Feelings evoked by certain types of landscapes are universal. Predictably,

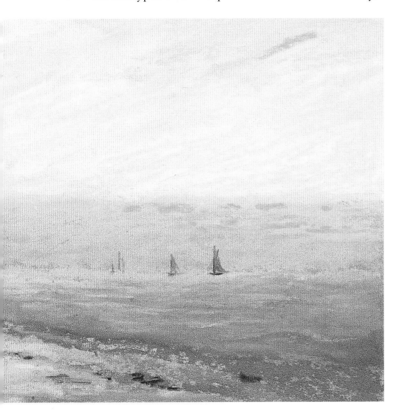

the open sea speaks to us of freedom or infinity or even power, just as the edge of a woodland symbolically offers its protection from the openness of a prairie. There is no question that nature also includes rare phenomena. At some time nearly everyone sees rhinoceros clouds, or twisted trees, or rock formations reminiscent of cathedral spires. People travel far to view the spectacular geologic attractions fashioned by nature over the millennia, but these are not the features embodied in poetic landscape.

In his own time, someone said of Corot, "He is no seeker after reality, he is a dreamer, who, through all the changing and varied aspects of nature, pursues always the same poetic, uniform note." Poet-painters dismiss the rarity. They paint every person's trees and every person's clouds. The roads in their compositions are roads that most people have driven along or walked through at some time in their lives. There is a strong correlation between the common natural landscape components in a painting and the degree to which all people can relate to them.

Poetic landscape occurs when one can feel the whole season from a painting of a few autumn trees or an entire country from only a painted glimpse of it. It occurs when some magical alchemy fuses the momentary with the timeless. A viewer will respond more directly to a painting when there are fewer transitions to be made over spans of time and distance. And because of this, if a landscape painting requires an explanation or specialized information, for most people the painting loses its poetic capacity.

An even deeper exploration of the poetic reveals that sometimes it is not so much a matter of avoiding the oddity when painting, but more a matter of

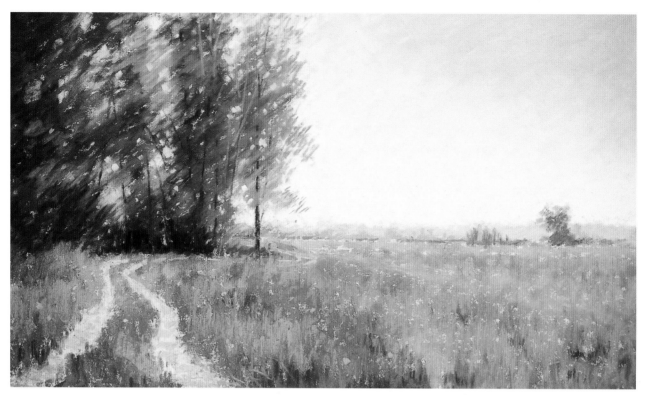

GIVERNY ROAD
8 × 12 inches, pastel, 1996

*A small dirt road edging a field is a common site to almost everyone. The road in this compo-
sition is one most people can relate to as similar to another they have walked or driven at
some time in their lives. There is a strong correlation between common natural landscape
components and the degree to which all people relate to a painting of them.*

credibly and creatively painting something that often
occurs. Most artists feel no compulsion to paint rhi-
noceros clouds, yet often even among the best of
artists, the way in which something common like fog
is handled can determine whether a work is bizarre
or poetic.

By avoiding the specific, the odd, and the rare,
an artist will usually find it possible to concentrate
so fully on the familiar that the common becomes

exciting. When explored to great depths, the familiar
transcends the common and approaches the mysteri-
ous. This cannot occur when details of a particular
place are present because then they get in the way
of free association.

The most highly evolved landscape paintings are
impartial: An idea is simply placed on the canvas.
Neither weighted messages nor judgments lurk upon
its surface. Poetic landscapes have the unique duality

of strength and beauty but without a point of view. The creator of them is not forcing a cause on the onlooker. Instead, the observer is given the opportunity to connect with the subject on his or her own terms. Personal associations are prompted by whatever part of the landscape brings past experiences or memories to the surface. In every case, the degree of connection will depend somewhat on the experiences the painter shares with those of the viewer. Even then, we can only see in nature or a

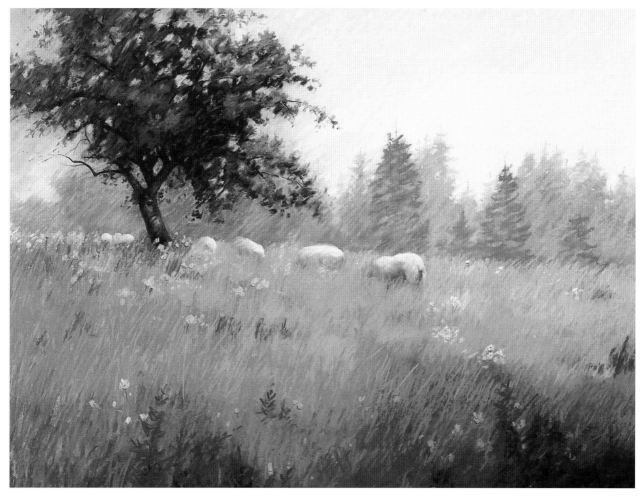

GRACE
22 × 28 inches, pastel, 1995

Sometimes sheep roam freely in vast open areas or along coastal hills that border the sea. I painted these in Maine from a study done on a magical morning. Landscape works poetically when there is harmony between the subject and the artist's idea about it.

painting what we are ready to see, what our mind recognizes at a particular time. Paintings, like literature and music, endure in our minds. They linger in the unconscious and resurface with more and more clarity as we evolve.

When free association is unhampered by the specific, a deeper sense of recognition is possible. As observers, we prefer to relate directly to nature. It follows that when we view paintings of nature, we would rather be unaware of the artist's technique or views and instead concentrate on our own attunement to the subject. We resist the influence of a middle person. Even the artist, as the arranger of the beauty, becomes cumbersome, adding emotional distance between ourselves and what we view, thus compromising the "free" in free association. In a Sierra Club book called *On the Loose,* one of the young authors, Terry Russell, says, "The point of it all is out there, a little beyond that last rise you can just barely see, hazy and purple on the sky." We need to believe that the point of it all is out there, and the concept of poetic landscape invites us "a little beyond that last rise".

The Indians believed in the natural world as a "living, vital being." Our growing awareness of the strong link between human identity and the natural landscape embraces the best of poetic landscape painting as a vehicle for understanding both the land and ourselves and the reciprocity that is necessary between the two.

Detailed, photorealistic, or complicated painting has much in common with the extrovert in that it reaches out for attention. It often pictures many things, showing all there is to show or everything the artist can fit within the painting surface. The artist "lays all his cards on the table," executing a "'what-you-see-is-what-you-get" image. This kind of painting can be appealing and dynamic. It is frequently the gallery or museum "showstopper." The wonder people feel about this type of landscape, however, is usually directed at the artist's incredible technical achievement. The impact is profound and immediate! Once seen and absorbed, the viewer "has it." If the painting becomes part of a collection, it may even become invisible to the owner after a short period of time, yet it would continue to draw fresh attention and admiration from each new visitor.

On the contrary, much of poetic landscape is introspective, its strength lying in what is left unexpressed. The same museum or gallery visitor who first came to a screeching halt in front of the "showstopper" may next be drawn to a quiet landscape previously overlooked. He or she may pause for a long time and then move away from the reserved but powerful scene with surprising reluctance. Such a work, though, can only appeal to viewers who, through life experience, have stored wealth within themselves, some part of which is triggered by the painting's evocative mood. They relate to the overall concept of the painting rather than its parts. Only after that initial connection is made do they allow themselves to be led into the painting. Once that occurs, the scene no longer belongs to the artist: It is theirs. Their own vague memories and ephemeral feelings mysteriously find a place to rest. Is the viewer seeking some bit of closure from the work he or she stands before? Maybe so. There is recognition

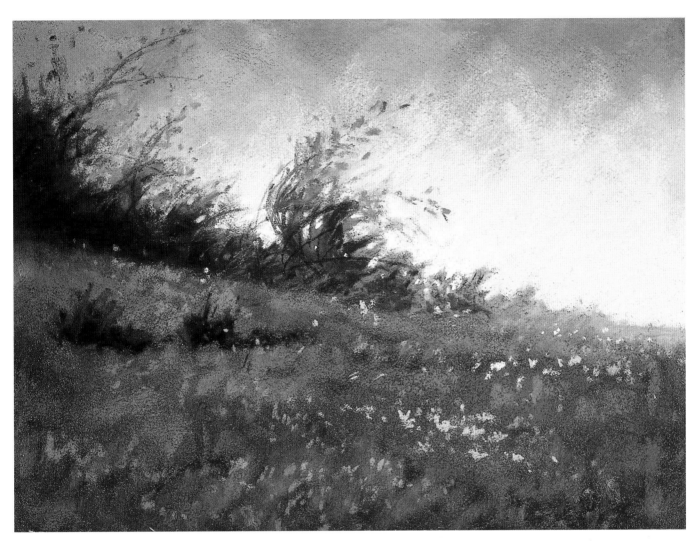

VERONICA'S LACE #6
6 × 8 inches, pastel, 1999

Much of poetic landscape is introspective, its strength being more in what is unexpressed. At such times one relates to the total concept of the painting rather than to its parts. This painting has personal significance for me, but may appeal to others on a vastly different level and for equally important reasons.

of something deep and substantial, yet elusive, just as when we speak with elderly folks who in their own wisdom wait to be invited before speaking, knowing through experience that everyone's personal journey through life has its own timing. Sometimes we are ready for an idea or a perspective, sometimes not. Everything in life has its season.

The relationship between memory and creativity has been studied extensively, and much has been published for the lay person in an effort to shed light on a topic that had been previously shrouded in scientific terminology. For most people, recollection of time and place is simply based on past experiences, and the painted poetic landscape sometimes

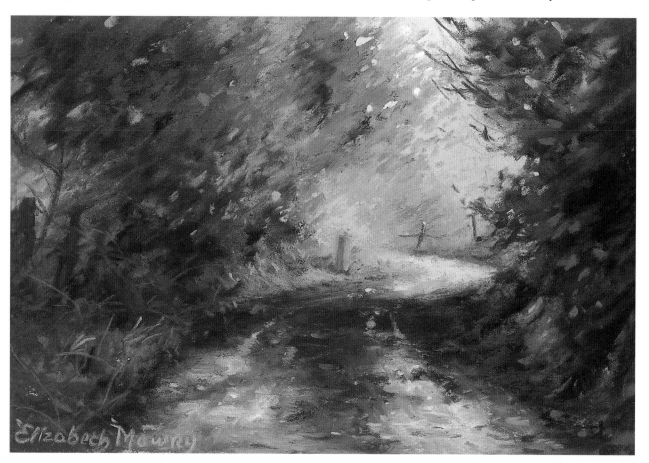

OPTIMISM
5 × 7 inches, pastel, 1994

This small painting of a wet road leads the eye through the shadows to the beckoning sunlight. It speaks clearly of optimism. Poetic landscape is attractive to the spirit of those who yearn to rest for a moment upon what is familiar.

refuels or puts to rest a part of the past that surfaces in the present. Growth and understanding continually take place by this ongoing integration. When a viewer connects with a particular landscape and attaches personal significance through memory, the momentary peacefulness that results is sure to be welcomed in a world where input overload is routine. The word 'nostalgia' is so over used today in marketing that it has become linked with connotations of 'cute' and with acrylic renderings of ducks marching across painted furniture. On an emotional level, however, nostalgia still has to do with recollections of beauty, peace, and solitude.

In *The Elements of Drawing,* John Ruskin wrote that for the artist, "it is the soul, not the eye, that sees." Spirit is not limited by the ticking of a clock, and poetic landscape today is attractive to the spirit of those who yearn to rest for a moment upon what is found to be familiar. Nostalgia is only one of many reasons landscape paintings speak to us. Nature is contemporary. Despite all the advances in technology, a tree is still a tree and a cloud is still a cloud. In addition, there are times when something the artist has painted in a landscape painting will trigger a particular human sense such as touch, smell, sight, sound, or even taste. The texture of shaggy bark on a tree or tall bending grasses in a field might recall simple tactile pleasures. A painting of a profusely laden rose arbor in the warmth of the sun or a trampled barnyard might stimulate the sense of smell, although in different ways. An autumn scene that includes burning leaves might do the same, or one showing bright sunshine on aromatic pine needles beneath a grove of trees. Here the visual image within

a landscape painting calls up and embellishes sensual memory as poignantly as a descriptive phrase in a good book, and maybe even more so. A depiction of sleet and bending branches could easily bring about reminiscences of biting cold and the urgency to find shelter. A frosty field might induce us to remember brisk crispness and the associated chill. Storms in landscapes speak of unrest or conflict and unease, an agitation of all of the senses.

Even sounds can be depicted within a painting. A flock of low-flying crows over a cornfield may invite associations with raucous cackling; a pair of mourning doves on a fence call to mind their distinctive lilting call and their pinwheel-like fluttering. Church steeples bring to mind bells chiming to announce beginnings or tolling to affirm an ending.

The counterpart of sound in paintings is silence. It is difficult to explain how silence or yearning or loneliness is portrayed, perhaps not intentionally, but it does exist in poetic landscape, real and painted. N. Scott Momaday, a Kiowa Indian and Pulitzer prize winner, gave us a hauntingly beautiful vision when he wrote, "Loneliness is an aspect of the land. All things in the plain are isolated. There is no confusion of objects in the eye, but one hill, or one tree, or one man. To look upon that landscape in the early morning, with the sun at your back, is to lose the sense of proportion. Your imagination comes to life, and this, you think, is where Creation was begun."

Sensations are frequently vague, but when visually triggered in a painting by a personally meaningful symbol they become catalysts that enable us to enrich our lives by broadening our understanding.

Freud believed that art began as an early form of escape from reality, but his feelings about art and artists wavered profoundly. In 1927 he wrote, "Before the problem of the creative artist, analysis must, alas, lay down its arms."

We have developed theories for everything, from aesthetic values to the nature of art. Debates continue about what constitutes beauty and what place art holds in our daily lives. Some of these theories and debates disintegrate almost as soon as the ink is dry; others catch on; some endure. One of the most captivating recent explorations has to do with the artists' response to trauma. Gilbert Rose at Yale University writes in *Trauma and Mastery in Life and*

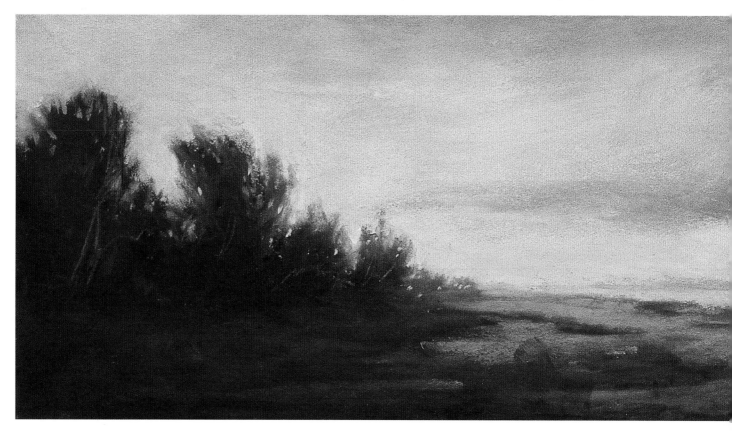

END OF DAY
4 × 10 inches, pastel, 1995

When sensations are visually triggered in a painting by something meaningful they become perceptions that enable us to broaden our understanding and enrich our lives. This type of subdued landscape might easily touch on feelings of isolation, melancholy, or acceptance.

Art about how the "wear and tear of everyday life" causes feelings to be bleached out of our thoughts and perceptions. He makes a case for using the creative imagination to reintegrate what was defensively split off, helping the individual to think and perceive with more feeling and thus to master inner and outer reality.

While Rose uses startling examples to back up his arguments, one cannot help but see the significance of his theory as it applies to all individuals in more ordinary situations. Almost all people have had loss of some kind, perhaps not to the degree of the colorful examples that are uncovered in the office of the psychoanalyst, but none the less experiences of personal loss. At the same time, individuals who have experienced loss may not be as aesthetically sensitive as the artist who can use work as a reintegration process. Poetic landscape can provide a subtle tool toward harmony and understanding. The senses provide access to the realm of experience we derive from contact with paintings and sculpture, music, literature, and nature.

For the poet-painter, a personal landscape exists within. It is a blend of imagination, memory, dreams, and aspirations, and most of the time it is hidden, except for the hints of it that spill out into the artist's surroundings, uncontainable splashes that color life's larger canvas. Our minds design landscape before it is manifested on our property or our canvas. Paintings with spiritual impact are often reflections of an inner landscape, and they create a bond between the artist and the place that, once shared with the viewer, becomes triangular. It is much like what happens when we recall a particular place from our past, thinking we "know" it. However, we never know everything about a place, no matter how familiar. What we learn is only more about our own lives and feelings. In some cases, it is the poetic landscape that makes this possible.

THOUGHTS ON RECOGNITION

Thomas Wolfe is right. Sometimes it's true that we can't go back home again without disappointment. Frequently the past is better left alone. Time and technology change our precious spaces while memory enhances them. When a painted landscape can transport us back to where the blackberries and the mayflowers grew or to a swirling brook where the trout were ever wary of the baited hooks we dropped into the water we feel kinship with a sense of place and what was and, even more, with a recognition of who we are and why.

Before I entered school, I spent much time with an old, gentle-mannered man who was the caretaker of a park that lay just beyond my backyard's gate. He tended the grounds and hillsides that led up to a view of the Hudson River. Jack-in-the-pulpit and the rare pink lady's slipper thrived there. Dogwood, mountain laurel, and rhododendron bloomed profusely. This was not a manicured estate, but a delightful wealth of natural paths that wound gracefully through trillium and may apple. Fragrant violets and lily-of-the-valley bordered the stone walls. Later wintergreen and peppermint flourished. I learned to identify the local varieties of trees. I knew where the patches of blackcaps grew. So that I could watch the little animals come out of their homes to forage for acorns and seeds I was taught to sit very, very still, with my finger to my lips.

My elderly friend always carried a sketchbook in his vest pocket, and it was filled with exquisite sketches, each one carefully labeled. I still remember watching as he placed a sprig of winged maple seeds on a picnic table. He picked up the seeds, turned them around and around and put them down again, and then looked some more. Since I was only about four years old, patience was not one of my strongest attributes, and I finally asked, "Mr. Marnett, are you EVER going to make the picture?" My friend only smiled his twinkling, warm smile and said, "In time, my child, in time." It was then I should have learned a most important lesson in art: There must be an impression before expression. Before we attempt an interpretation of anything, we must first "know" it thoroughly enough to become emotionally involved in it.

We were comrades for several years, this old man and the child that was me. We roamed the park together, we lined the clay courts each morning before the tennis players arrived, we collected blooms and berries. He never seemed to tire of my endless questioning. This was the only naturalist I have ever known firsthand. One day he didn't come to the park, nor the day after, and not ever again. This was the nature of my first encounter with death. It was time for Mr. Marnett to rest and time for me to move on and go to school. For me the transition was a sad one.

But now I paint trees and flowers. I am who I am because of all of my experiences. I still love to spot a wild strawberry patch and a shagbark hickory tree. Recognition is a powerful force in our lives . . . a glimmer of unencumbered joy in childhood and one of the final pleasures of those who have grown old.

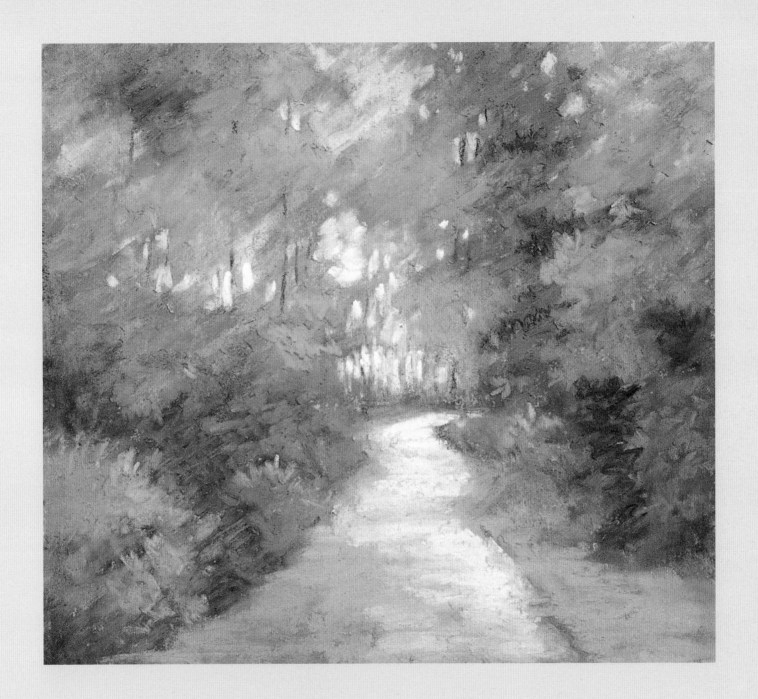

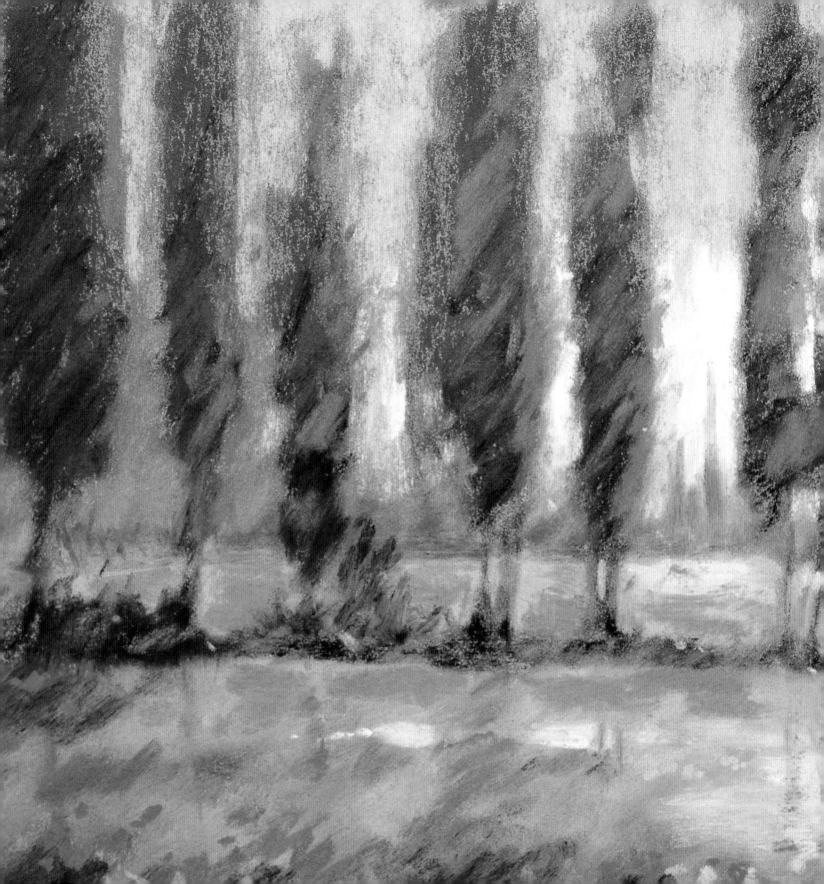

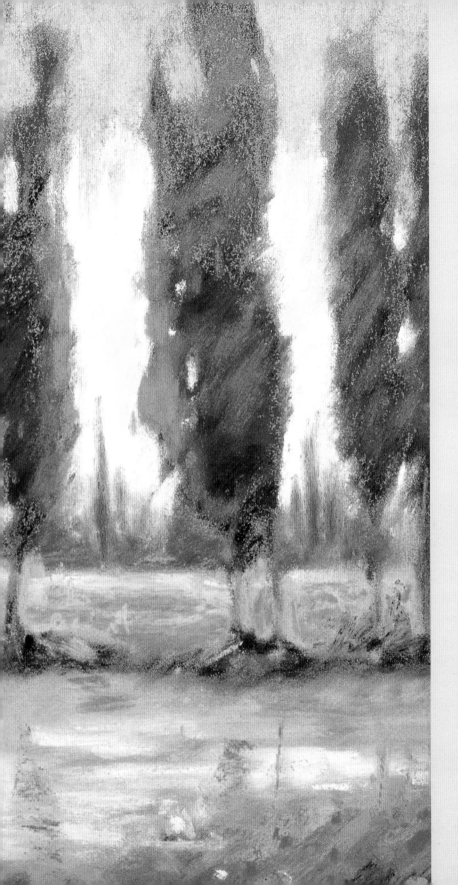

The Grace of Line

"To read the landscape like a book,

as well as to enjoy it as a picture,

opens the way to a new relationship

between men and their environment.

The health of the landscape, its

appearance and men's response

to it, are interdependent."

SYLVIA CROWE, *THE PATTERN OF LANDSCAPE*

The graceful line is sought after in nature by the poet-painter as an inspirational armature for compositions that transport the beholder beyond the paint and the canvas to the spirituality of place.

Nature's vast diversity provides the artist with many combinations of line including the verticals of trees, the horizontals of expansive fields and lakes, and the diagonals of sloping mountains or cliffs along the shore. And nature is the undisputed master of the curved line. When the artist uses the curve as a major compositional component, it is likely that the painting will exude peacefulness. One might think of the meandering line in landscape as the 'andante' of painting. Although we commonly familiarize ourselves with beautiful music by the popular 'allegro' movement, it is the exquisite juxtaposition of lively and slow movements that gives unforgettable music the unity and impact that renders it poetic. In landscape painting, what is important is the emphasis on the melodic 'andante' to create an elusive, even haunting, bonding between the land and its observer just as it magically happens in music between the score and the listener.

In nature one can sometimes observe a graceful compositional line that moves through the landscape. It might begin with the arch of a tree branch and then show up again in the gentle curve of a distant mountain and then finally appear within the lilting grasses and weeds in the foreground. This type of meandering curve visually sets the stage with its quiet and restful movement so that impact occurs when the abrupt line of a rooftop is introduced, however small or distant. Unbalance seeks balance. In this case, the predominance of curved lines forces

RIGHT
BLUEBERRY BARRENS II
5 × 15 inches, pastel, 1994

BELOW RIGHT
BLUEBERRY BARRENS III
5 × 15 inches, pastel, 1994

Both of these paintings originated from the same idea: roads leading through the expansive acreage of wild blueberry barrens that are a recognizable signature of the Maine landscape. Here they become evidence of human existence after the fact.

In the first painting the season is yet to come. The road is wet after an early spring rain, the mood is somber, but the curves of the road guide one into the painting toward the horizon. To some the landscape would suggest anticipation.

The road that curves through the second painting escorts the observer through barrens at the finish of the season. The mood speaks more of reminiscence here. Although the location is different in each painting, the curve of the road dominates both scenes. It illustrates the subtle rise of the landscape and it is able to hold that power because everything else within both paintings is subdued.

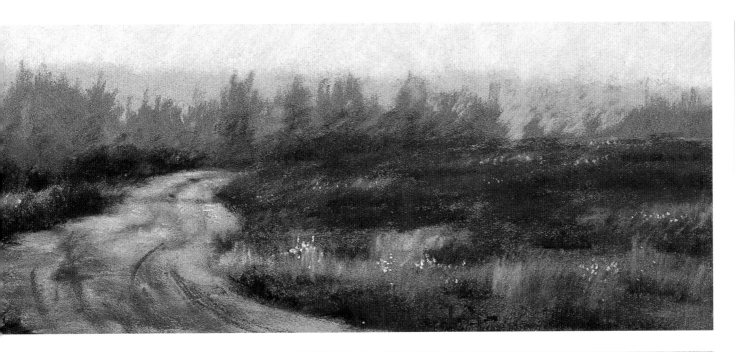

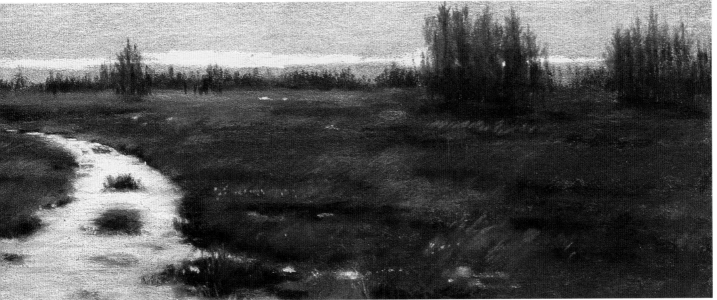

the mind to attach weighted significance onto the tiny angled roof. It becomes a focal point and encourages the viewer to sense the mystery or poetry of the scene without having to define it.

Although our topic is landscape, it is interesting to note that the reverse would occur in a cityscape comprised of the staccato structural lines of buildings and streets by introducing a simple bird's nest made up of curved twigs onto an angular window ledge. Using line effectively sometimes consists of composing a scene and then introducing an element of line that surprises.

A circular line often evokes a sense of harmony, whereas straight lines in patterns of opposition might not. For example, a painting consisting of all angular rocks might be striking as well as exciting, but less poetic than one of flowing water edged by bent grasses and only a few rocks. It is possible to set up a landscape composition just as one sets up a still life arrangement. The artist can artfully evoke mood through line.

Line is the strongest compositional element that an artist can use to guide the viewer into a painting or through a painting, or, as we have seen, to intentionally abandon the viewer somewhere within the painted landscape. A few of the most common natural lines of penetration into a real or painted landscape are rivers, roads or paths, shorelines, and hedgerows. They all transport the viewer by providing an unmistakably clear direction into and through the landscape. These serpentine lines of grace are important silent mentors for the viewer's eye, and in the truly poetic painting, for the viewer's heart as well.

Linear patterns in nature range in scale from the grand outlines of the highest mountains to the intricate patterns of the smallest pebbles along a winding stream. Geometric shapes consist of angular lines, points, or triangles. In the landscape they often appear in bridges and buildings. The character of such lines, when overused, can be imposing, even aggressive. Many of the right angles we encounter in landscape are the result of changes humans have initiated. Examples are homes and other buildings, and even walls, fences, and other boundaries. Humans are motivated by comfort, by productivity, and by cost effectiveness. Mankind is always rearranging for convenience. On the other hand, nature simply is.

The masterful use of line is particularly evident when an already pleasing view becomes poetic on the artist's canvas. Nature's swaying wildflowers, worn hills, and hazy trees set in the background are passive, and they merely allude to line. Sometimes line disappears completely, and then reappears at another place in the painting, giving the eye even more freedom to rest. It is this linear interplay of rest and activity that resonates the poetic in a landscape painting.

Lines that clearly define the shape of mountains, tree trunks, rock planes or the edges of structures fight for attention, and when they exist all over the canvas they shatter focus. Furthermore, if just one of those distinctive lines continues to the canvas edge, it takes the viewer's eye outside the painting. Softening or losing the edges of line makes it possible for the artist to contain the focal point. The viewer is then aware of the peripheral beauty of the scene, but enjoys the restful pleasure of relating to only one area, the center of interest.

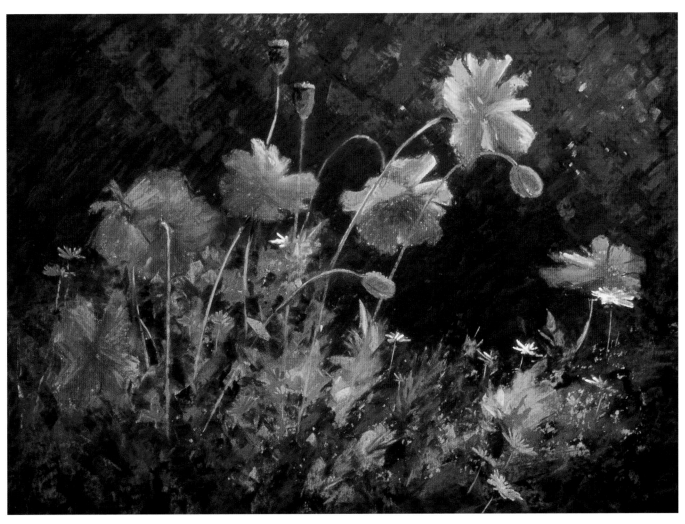

JOSIE'S POPPIES

18 × 20 inches, pastel, 1995

The graceful lines of the poppy stems and the conscious distribution of sunlight on selected flower petals and leaves guides the eye in a circular pattern just to the right of center in the painting. If the poppies and leaves on the left were equally prominent, the path would change from circular to linear and would be less interesting. For the artist, as interpreter, it can be exciting to play with the existing lines in nature and the potential to redirect them.

Ultimately, the artist's skill at determining where line will define the edge of a shape is critical to the success of a landscape painting. Soft edges diffuse a line. They unify landscape components by inviting one part of a painting into another. Executed with selectivity and expertise, the softened edge will not weaken a painting, but rather strengthen it as a whole. Softened edges are not a disguise for poor drawing or composition. The artist must know where all edges are or would be in a painting. It is then a conscious choice to show or eliminate them. Softened edges can be used to remove emphasis from any area that competes with the center of interest. Conversely, hard edges can direct the viewer's eye to a focal point, separate planes, or add a dimension of strength to a particular landscape component.

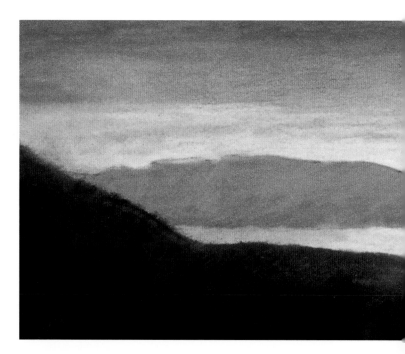

Our need for food and shelter has reshaped the natural landscape over time. Terraces and vineyards sculpt the hillsides in many places throughout the world. Sweeping patterns of flooded rice plains define the landscape of distant countries, while ploughed fields accentuate the contour of the land in others. In winter, a graceful line of forlorn cornstalks curving toward the horizon is quiet evidence of our partnership with nature. In France, lines of poplars or cypress trees are common. The discerning artist will use such a strong linear pattern as an underpinning for elegant compositions. Much of the appeal of the European landscape stems from the fact that the fields and pastures are characteristically edged with hedgerows or stone walls, fences and woodland. When, for economic reasons, these lines are removed, the landscape looses its intimacy.

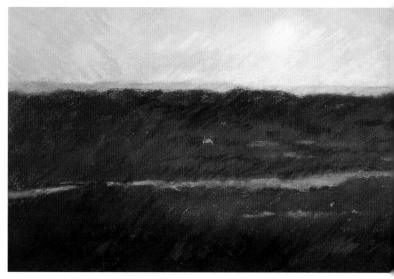

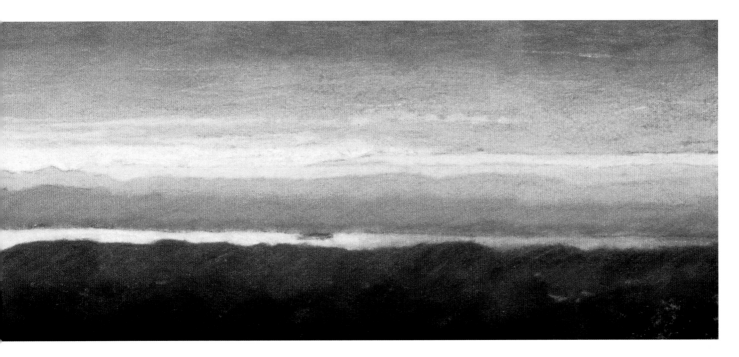

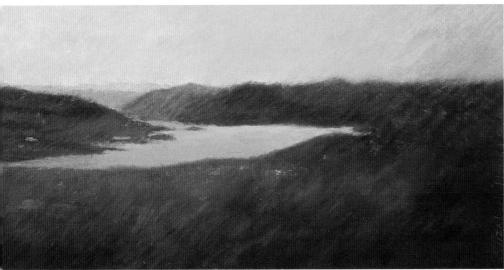

ABOVE
**HUDSON RIVER
AERIAL VIEW #2**
6 × 20 inches, pastel, 1994

LEFT
**HUDSON RIVER
AERIAL VIEW #3**
6 × 20 inches, pastel, 1994

In the first painting the eye must make its way up to the horizontal line of the river before it can stretch across the complementary format of the painting. In the second version of the same subject the slightest curve of the river gently encourages one through the foreground and into the painting more easily. Both paintings are studies of light on a ribbon of water as it winds through the valley.

Humans develop character over time. In nature, some aspects of the maturing landscape cannot be hurried; others happen so fast that one dares not look away for long. Photographs of the same place at different times will confirm this visually and vividly. Old fruit trees, no longer pruned, waiting in the orchard to be cut down and replaced, are often much more graceful than the younger trees that are severely pruned in order to bear abundant fruit. Just as a toddler may be cute, the carved physiognomy of his grandfather may be far more interesting. Nature often acquires a grace of line that simply comes from existing longer.

The artist communicates with the viewer through line by using it to make a unified concept flow through the painting to what is most important. At all times of the year, the masterful painter can find nature's graceful lines and use them to paint memorable landscapes. The amateur, on the other hand, may experience disappointment, not simply because skills are not fully developed, but because of indiscriminate choice of subject matter. The ability to choose subject matter comes under "the art of seeing," which, although unteachable, can be attained through familiarity with the intricacies of nature and

BEACH LINES
5 × 15 inches, pastel, 1994

Familiar patterns of beach debris left by a recent tide softly echo the water edge that stretches toward the horizon. This is an example of the irregular repetition occurring in nature that invites the viewer into the landscape.

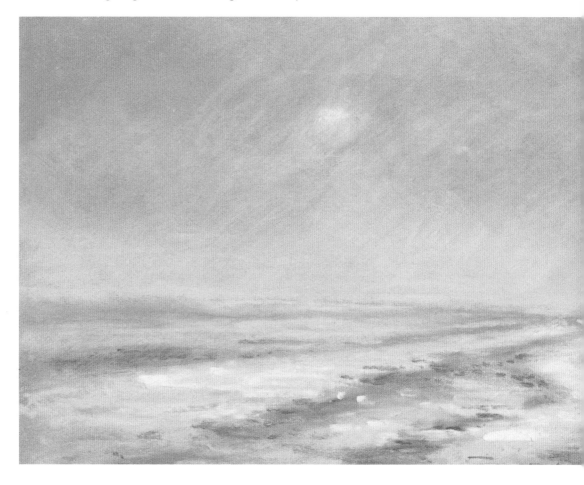

the practiced experience of composition over time. For example, the inexperienced eye is likely to be attracted to the young colors of spring, and in so doing, may not see that the new growth of flowers and plants lacks the expressiveness of line that exists in mature vegetation. Of course, if one's purpose is simply documentation, this need not be a consideration. However, for the landscape painter seeking the painterly, it is just one of many aspects of nature to take into account. The upright, just-planted look of many early spring gardens leaves much to be desired with regard to shape, overall form, and spontaneity.

The experienced artist may pass by an immature subject only to return three weeks later when the composition has acquired a greater degree of expressive line. So often it is this matter of degree that makes a difference.

Another type of line that must be considered in any landscape painting is rhythmic line, particularly the line of repetition. A natural, tree-lined path is impressive, the repetition of trunks rising toward the sky, all catching the light at the same side, defining the differences and similarities of the trees. Even negative spaces between the trees make up a vertical

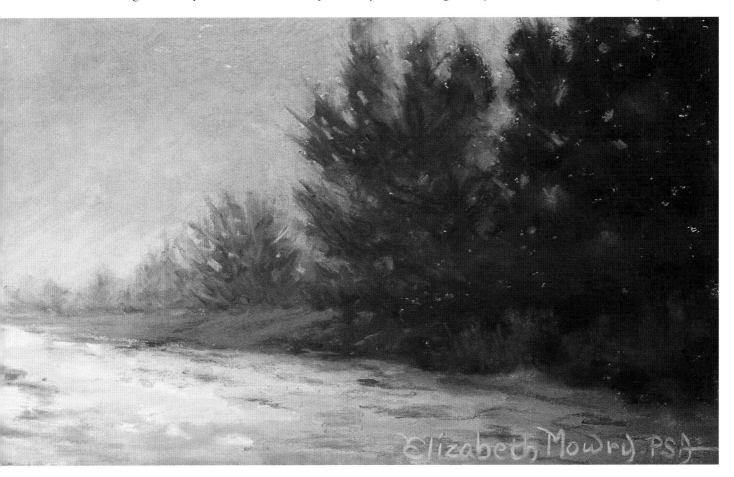

pattern that echoes the design. The arches of a bridge provides another rhythmic line, one that reflects the hand and technology of mankind.

Telephone poles and fence posts can also set up a spaced rhythm throughout a landscape—verticals set up by humans but often tilted this way and that by natural forces such as wind and rain. Repetition also occurs in lines of washed-up seaweed and shells along a beach at low tide and in the windswept, patterned ridges of shifting sand dunes. A repetition of

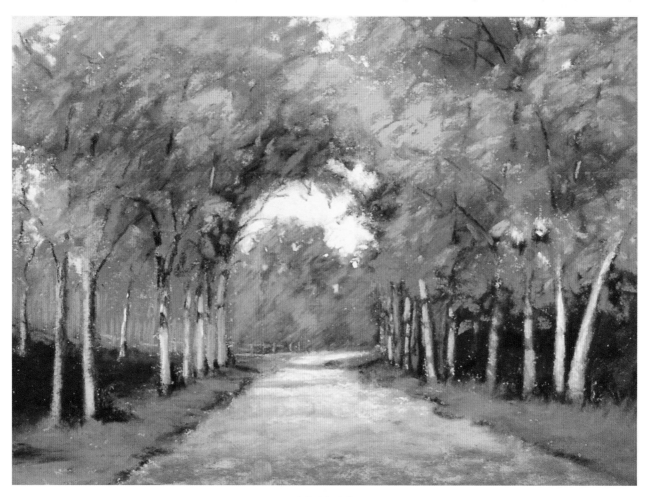

ARCHES
5 × 7 inches, pastel, 1996

Tree-lined roads throughout Europe often provide a natural frame for the landscape beyond. This road leads to a tiny village where the only street is graced by a deservingly popular bakery, not to a magnificent estate. I painted this study from a photograph that was taken from a moving car on the way to the bakery for morning croissants.

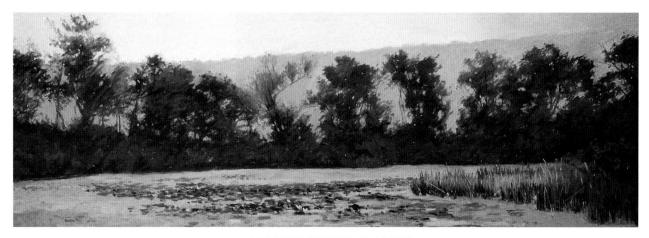

AUGUST RIVER DANCE

12 × 34 inches, pastel, 1999

The rhythm in August River Dance *represents nature's unpatterned repetition. It's unlike a painting of a long bridge in which all of the arched shapes are precisely the same except for the perspective. Here the graceful trees that line the banks of the algae-covered water make their own subdued design across the painting.*

a distinct shape can also create an interesting line through a landscape: Think of islands in the water, bales of hay in a field, or water lilies in a pond.

Transitional areas where land meets water or meadow changes to woodland are known as linear "edges," places where two different kinds of landscape converge. It is here that the story of the land can be most interesting. The poet-painter will frequently develop the focal point of a painting along such an area of transition.

Enhancement of a focal point can also be achieved by using line to frame a part of the subject. Natural framing occurs when a shadowed trail opens to the light somewhere in the distance. It also occurs when trees arch over a road. A delightful example occurs throughout Normandy. There, along the roadways, hedges thrive and trees seem to reach over the road to enclose it protectively. A focal point is always intensified by this type of natural framing.

Sometimes in a most unassuming landscape a meandering line of trees or a hedge can powerfully express yearning. The curved line has the potential to be beautiful just because of its unstifled, natural form. In landscape painting, when parts of that line disappear from view but the motion of the line continues unseen and then reappears dramatic and magical silences are created. Those silences underline and lend more emphasis to the visible lines in the painting. Paintings consist of what is there but sometimes even more of what is absent. The poet-painter is responsible for the painted strokes that compose the melodic rhythm between chords struck and silences observed in a painting.

THOUGHTS ON GRACE OF LINE

My ongoing quest for simplicity of line frequently draws me to that horizontal part of the landscape that we refer to simply as "the field." When I walk in the woods, I feel the presence of the unyielding rocks, the character of the trees, the slope of the mountain, and the activity of water in the stream, as well as the animals who drank from it the night before. All these contribute to an exhilarating excitement.

But then I leave the woods and step out into the open field, and suddenly there is calm. The passive field stretched out before me, with grasses softly rippling in the breezes, invites freedom to run, to breathe deeply, to hum melodies, to feel peace, to know "I am." There is no conflict here. The field is nature's ultimate example of acceptance. It is still and quiet in its beauty. It bows to the winds that bring seeds to its soil; it absorbs the rain and the sun and the snow with gracefulness; it does not fight back. The field is gentle and soothing, and although it holds shadows of all that surrounds it, it remains of its own. Then in the spring, it gives back grasses and flowers, or corn and hay. It is part of a simple cycle that is a lesson to mankind of endurance, perseverance, and continuance.

In painting, the field can be an inviting foreground to a majestic panorama, or in the background, a quiet valedictory. Where humans have rearranged the landscape, the field might be lively with pumpkins; left alone, it can be desolate with rocky soil and only a few tufts of grasses that are bent by the winds. The effects of weather on the field offer infinite variation for the painter. There is no sheltered protection from the elements out in the field. The rain falls harder, the winds blow more fiercely, and the sun beats hotter. The scene may be simple, but the challenge is great.

A walk in a field has a leveling effect upon the soul. Over the years, I have gone to the field in sorrow, head bowed, shoulders drooped, and I found solace there. And I have returned to the field as many times in wild joy, arms outstretched, whirling in circles with wild abandon, laughing to the clouds.

I have painted the field again and again, close by and far away. The grasses that blow are of different varieties, the wildflowers are different colors, but the secrets of the field are the same. I have gone to the field hundreds of times expecting nothing. Instead, I go for the sheer joy of being there, and I have always returned fulfilled.

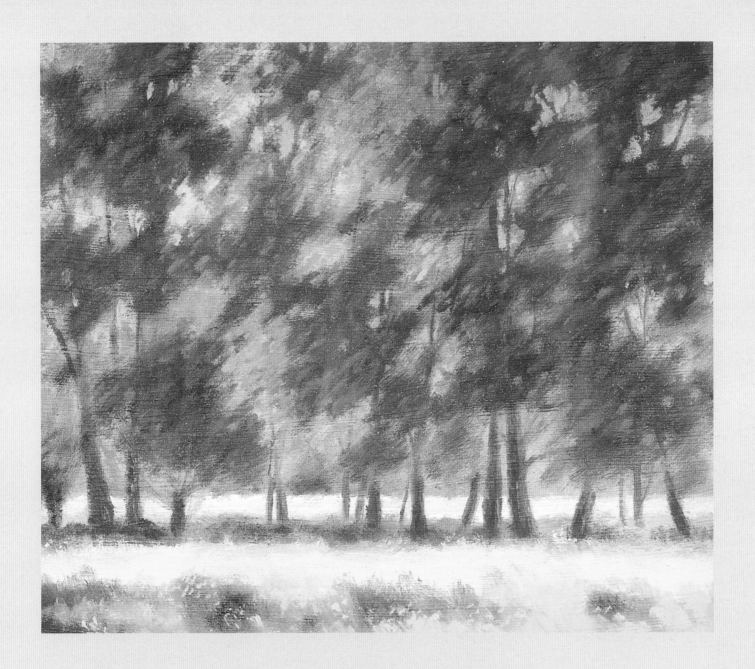

The Vista and the Intimate Landscape

"Some special places have the

extraordinary power to serve as a

metaphor for the whole world.

The power often comes from a

concentration, a reduction to essentials,

and its effect is altogether to absorb us,

to hold us in the spell of the place."

THE POETICS OF GARDENS

The poetic and the spectacular in landscape are not identical, and nowhere is this more obvious than in a study of the grand vista. Comprehensive views of the land from places that overlook great distances can be spectacular, thus the worldwide popularity of the panoramic postcard. Anyone who has climbed to a mountaintop knows the breathless exhilaration of seeing an unobstructed view of mountains and rivers winding through fields and valleys below for hundreds of miles. Yet often within seconds the satisfaction of having met the physical challenge of the climb yields to humility as ego bends a knee before grandeur. When our feet are planted on mountain-

sides or at the edge of canyons and we see the final shafts of sunlight transforming gray rocks into shapes of glimmering pink, golden orange, and unmixable shades of purple, color theories seem ludicrous. "This," we exclaim, "is beautiful." The spectacular invariably holds inherent beauty, whether it be glorious or haunting. But is the spectacular necessarily poetic? Not always.

The scenic vista reveals landscape on a large scale, taking in great distances and many different landscape patterns. Viewing a painting of a vista that adheres faithfully to reality, the viewer will scan the painting in search of a focal point. When the painting

as a whole resists such a visual resting place, the view is more likely to be spectacular than poetic. Some large vistas may not fit into the realm of poetic for various reasons. There may be astounding color or light evenly distributed over the surface; there may be hard-edged contrasts throughout (typical of realistic painting); or there may be an abundance of detail throughout the scene.

In nature, scintillating color frequently rages evenly over a scenic view, making focus elusive. In painting, the competitive stress of so much color on a single canvas is exciting but unsettling. Sunlight may also fall uniformly onto a landscape, and, as

photographs show, cause the eye to be pulled every which way by patches of light. In a poetic painting of a grand vista, the artist-poet will frequently unify color, as well as areas of dark and light, by making adjustments that direct the eye to a particular area.

When a scenic vista is complicated by many landscape components, the spectacular and poetic are also not parallel. Think of a scene with dramatic clouds, snow-covered mountains, rocky hillsides, colorful wildflowers, and perhaps a waterfall. In such a composition, each awe-inspiring part of the landscape competes for the viewer's attention. In contrast, a poetic landscape painting is choreographed

LEFT
HUDSON RIVER HIGHLANDS
10 × 60 inches, pastel, 1998

BELOW LEFT
HUDSON RIVER FROM KYKUIT
10 × 60 inches, pastel, 1998

Both of these views of the Hudson River take in miles of reality that include the sky, distant mountains, water, and the foreground. To make the paintings work in a painterly way, I had to make decisions about color and composition that weren't based on reality. I also used techniques that eliminated almost all foreground detail.

COLORADO COMPLEMENTS
20 × 39 inches, pastel, 1995

Anyone familiar with the highway going west toward Vail, Colorado, drives past this location. In my interpretation the condominiums at the far side of the water do not appear. Emphasis shifts to the wildflowers in the foreground that catch the light.

to emphasize a selected area deemed important by the artist who employs any number of painting techniques to accomplish the desired effect.

Too much or poorly placed detail will also prevent a painting from being perceived as poetic. Artists can dissolve detail by softening painted edges or by using color values that are similar, both of which reduce contrast so that the painted view becomes more integrated and expressionistic, not simply realistic.

In short, a grand vista gives us much to absorb. When each area is treated equally in a landscape painting, as each appears in nature, the view inspires awe before reflection can take place. In an artist's painterly handling of the same scene, a restful reflection is initiated sooner.

Before beginning a large painting of a grand vista, the artist must interpret the scene according to personal vision and then keep that vision constantly in mind as the work progresses. A large painting can easily become fragmented when clarity of concept is not well-conceived or adhered to. If the painter is successful, the vista can be both spectacular and poetic. What is really most important is that the artist skillfully selects a focal point for the viewer.

The vista characteristically evokes a sweeping vision. As we view the scenic panorama, we obtain a sense of how many different geographic components come together as they do. Patterns emerge. Light and shadow lend reason to shapes and size. We "read" the land. The height of mountains and bluffs, the slope of weather-worn hills, the slow penetrating movement of water all reveal nature's laws in action. We visually understand why vegetation is abundant in some areas and sparse or absent in others. Harmony predominates and our human anxiety about making sense of things dissolves as we stand before a grand view and perceive it as a whole.

Vista, the vast expanse of open space, appeals to our sense of freedom. Nature, on this large scale, can be easily associated with feelings of openness, clarity, release, and joy. Psychologically, this type of landscape is generally positive and embodies looking ahead to the future—goals to seek, growth, and the unsung wisdom that quiets the yearnings of the soul. As the eye of the beholder penetrates the grand

landscape, sometimes helped along by a bit of road or waterway, many natural elements are seen. What is important is not the separate rocks and trees, water or sky, but how all of those landscape components fit together. Visual symmetry and rhythm in nature bring the larger picture of our own lives into focus.

The intimate landscape—the opposite of the vista—conjures up thoughts of "small," not of the painting's size but of its scope of content. Here it is important to remember that although content is limited to only one or a few natural components, the subject is not diminished. In fact, when focus narrows, importance usually increases. Even the way we view the scene changes: With the vista we scan, with the intimate landscape we investigate. We move from the general to the specific. Painting techniques are also different. Texture replaces aerial perspective as depth takes precedence over height and width. The content inherently is the focus. Individuals will either relate spontaneously or not, depending upon whether they have ever taken special notice of the same subject matter. The intimate landscape is a personal sharing by the artist of a single impression elevated by thought and talent to a place on the

ÉTRETAT
8 × 19 inches, pastel, 1997

The magical quality of the light in Normandy unifies color to such a degree that I felt no compelling need to change it in my painting. I kept the foreground uncomplicated even though the opportunity for interesting detail existed. This impressive vista was a favorite of Monet and many other landscape painters. I include my version of it here because I feel so privileged to have been at this enchanting place.

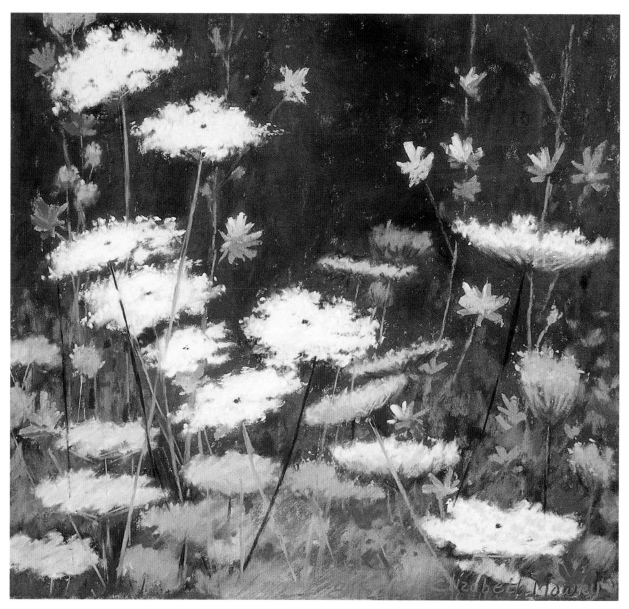

QUEEN-ANNE'S-LACE
9 × 10 inches, pastel, 1997

This common flower throws quiet dignity over a field or a mountainside. Here I painted the open and closed shapes that I found so interesting as they mingled with summer chicory. With intimate landscape, individuals will either relate spontaneously or not, depending upon whether they have ever taken special notice of the same subject matter.

painting surface. Usually the artist has studied the content closely, noticing harmony of detail, color, distinctive line, the effects of light; from this personal assimilation, the artist offers an interpretation. The result is intricate and immediately personal. The intimate landscape is common; it is everywhere. The discerning eye finds it in backyards as easily as in national parks. The artist compresses the vista to fit the painting surface but expands the intimate landscape to illuminate our understanding of it.

The intimate landscape suggests that we are part of nature, not looking at it from a vantage point. Examples include the edge of a water-lily pond, a winding path through dunes, the intricate patterns

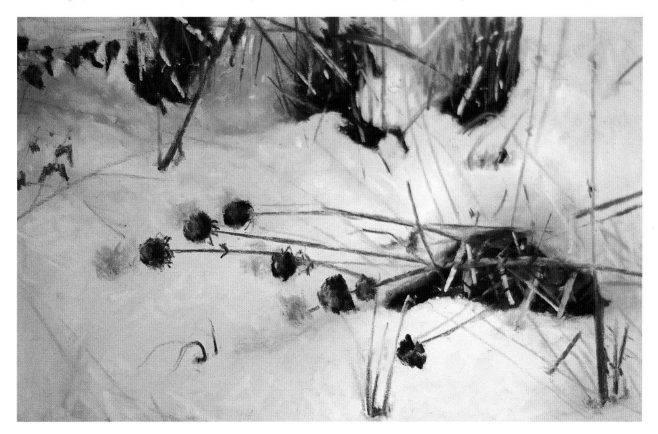

DAISY HEADS IN SNOW

5 × 8 inches, pastel, 1993

While walking through my field in winter, I came upon some common daisy heads, withered and broken, but somehow still majestic within the purple snow shadows on the cold white snow. Although content in an intimate landscape is limited to only one or a few natural components, the subject is not diminished. Quite to the contrary, the importance of that which is pictured usually increases.

found on a snow-dusted stone wall, or the play of sunlight and shadow on the branches of a spruce. The artist discovers these intimate compositions by zeroing in on nature much the same as a photographer uses the macro lens on a camera. It is simply a visual cropping to zero in on what the artist finds most interesting within a larger context. These intimate landscapes can actually become abstracted when the subject or content of the painting is no longer recognizable due to extensive cropping. When this occurs, nature's landscape components are transformed into design elements.

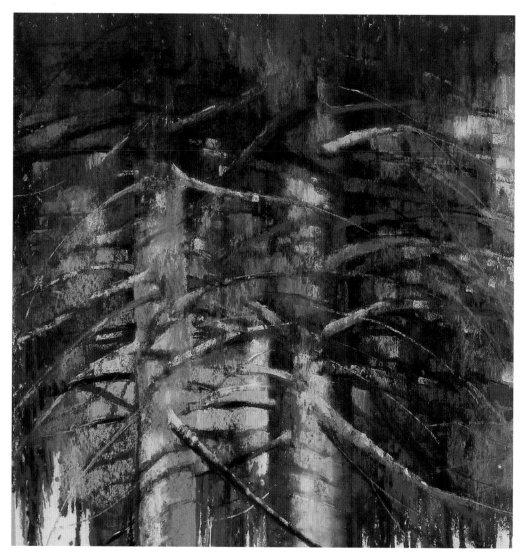

SPRUCE SHADOWS
15 × 15 inches, pastel, 1992

When we zero in on nature, we are visually cropping the landscape down to what we find most interesting at the moment within the larger view. Some of these intimate landscapes become abstracted when the content of the painted subject becomes unrecognizable because of extensive cropping. The content is transformed into a design.

Intimate landscapes, just the same as all landscapes, may or may not be poetic. When technique overwhelms the viewer paintings will not be poetic; through expressive interpretations there is more likelihood they will be. In any event, when the beholder has personally witnessed the same small portion of nature portrayed by the artist, recognition occurs. Very often, the viewer is pleased to observe that some small, familiar part of nature has been elevated by the artist to the content of a painting. When this occurs, there exists an immediate bonding of artist and beholder of the art that transcends mere recognition.

In scale, the intimate landscape is the opposite of the grand vista. Accentuating this contrast of scope is the narrowing of content to a small natural area, which is depicted in a way that reflects the artist's intimacy through the use of detail and texture and even illusions to scent and sound. All of these would be familiar only to those close to or part of the scene. Because the intimate landscape features only one component, or simply a part of one, focus is singular, more evident in depth than in breath. It is a solo, not a symphony, a monologue, not a debate, a tiny Belgian chocolate, not a soufflé. Sometimes we crave one, sometimes the other. Our mood, energy level, and outlook, and what we are experiencing in our lives, all determine the kind of real or painted landscape that will quiet the sigh in our breast. Both the grand vista and the intimate landscape can be meditative sources of peace and resolve as we continually assimilate the past, present, and anticipated future into a celebration of now.

THOUGHTS ON THE VISTA AND THE INTIMATE LANDSCAPE

I remember the purple mounded heather in the Scottish Highlands stretching toward the horizon without a single dwelling in sight. Ancient military roads wound through the rocky hills under skies more dramatic than anywhere else I had been. Sheep were everywhere, standing rigid on the hills, their deep wool parted by the relentless winds. And then the rain—sometimes softly falling out of the blue mist, other times diagonal, even horizontal, pelting, continuous—an eerie force that prevented even one step forward and more often pushed me backward. Drenched to the skin, cold and windbeaten, I would have gladly traded my camera for a dry Kleenex and a cup of hot cocoa. Yet, when the dark clouds rolled away to reveal a cobalt sky above an unforgettable vista, I was grateful for the rewarding experience. As humans trying to control more and more of our lives, we need to be reminded of nature's power. The vista leaves us in awe of its quiet forces.

There are other occasions when time is limited, that shorter excursions into the landscape provide opportunities to find our center nearby. As opposed to viewing nature from a vantage point, a daily walk can draw us intimately into it. It is always a privilege to witness nature's changing cycle up close. In January, saffron skies glimmer behind dark masses of hemlock and spruce. I enjoy the restful lull of February with its squalls of whirling snowflakes that remind me that winter is not over, and I am attracted by the austere simplicity to which everything around me has been reduced. The stars appear brighter. The moon triumphs. Then in March the hepatica blooms through patches of snow and an explosion of growth and color follows. Wildflowers fill tapestried fields with buttercups and clover. Moist air brings out the heavy scent of grasses and twining honeysuckle. This is a turning point for the artist. Earlier I seek out material and each subject is solitary and defined. Now shapes merge. Foliage hides the structure and closes in the open spaces. An intelligent simplification becomes necessary as I replace searching with sorting. In July another lull occurs as tall growth stands quiet and still and the noon sun lies hot over the mountains after steaming off the early dew. In the woods, lichen-covered rocks rest in shadowy soft mounds of moss. The smell of pine permeates the heated air. The lack of fixed form is enchanting in its full-grown grace. There is no movement, no breeze, only widening ripples in the drying pond where insects touch the surface. The incessant hum of katydids increases as daylight wanes and gives way at dark to the raspy night music to which the fireflies dance. In August, the peepers keep up their monotonous song, the only one they know. Iridescent blue dragonflies approach, and stop, suspended for a moment. Along the dusty roadsides bowing sunflowers are heavy with seed. In the orchard tree boughs are pulled toward the earth by fruit. Then berries ripen, evenings lengthen, crows call. The milkweed bursts and colors mature. The last of summer storms brings a final rainbow and then some evening, without warning, the frost arrives and leaves begin to fall almost silently. Wind from the north makes summer a memory as it rattles through

the leafless trees and roars across the fields, blowing the last bright color from nature's palette. There is a quiet strength in the essence of what remains. Nature's cycle completes itself as the ground becomes hard and again the snowflakes begin.

Our moods and needs determine the type of landscape that centers or excites us. For an artist, attunement with nature can move full circle too, inspiring both masterful paintings of vistas and intimate landscapes and the unity that exists between the two.

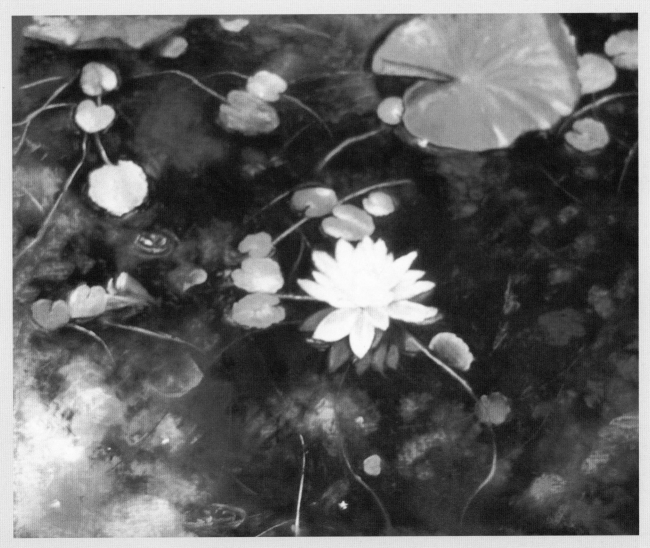

The Artist and the Poetic Landscape

"Now I know that great men

have no other function in life

than to help us to see

beyond appearances."

JEAN RENOIR, *RENOIR, MY FATHER*

The poetic in landscape painting is not something attained by grasping. It can only be harvested, by a quiet eye and an exacting brush. It is a matter of getting beyond craft to the tenuous space where intellect and spirit direct technique. Excellence of craftsmanship is a prerequisite. Without it, the painter functions ineffectively, the end always a frustrating disappointment compared to the beauty of the concept.

Realism in painting is easily attainable by so many. The poetic in landscape has to do with mood, ideas, and design, all ethereal, not realistic. When a perfectly executed painting is finished and the question is still "What now?" there is no poetry. Reality is a starting point. We set up the reference, add or chisel away at it, and then continue to mold and shift it until the reference is buried and something new takes its place.

The painter today has a choice: to break new ground and try to do what has never been done or to paint the uncommonly common in a way that reflects insights that are personal yet unique for anyone who encounters them. In either case, the success of the work depends upon how profound the artist's life experiences have been. The goal of both choices is to put a little bit of the universe into a painting so that the artist's legacy to nature holds an imprint of hope for future generations.

Sentiment toward landscape painting has fluctuated between the laudatory and the unfavorable for years. At worst, landscapes have been simply ignored; sometimes even excellent landscape painting has been treated with haughty indifference. But, as with all subjects and styles, the pendulum swings: Recent landscape exhibitions in some of the most renowned museums in the world have been overwhelmingly successful and well attended.

Why does the prestige of landscape painting fluctuate? First, masterful landscape painting has been around for a long time, so the subject itself can be viewed as old. If everything about it has already been done, and it has been done with excellence, why keep doing it? It is believed by some that no new challenge could possibly exist. But is this really so?

Many things are different today. Consider our changing ecology, the heightened response of the modern viewer stemming from an intensified quest for harmony, and a young generation of artists with a sensitive attunement to the earth. In fact, the challenge appears perhaps greater than ever. The reasons behind our views, values, and needs must always adjust to a shift in priorities; and if all reasoning is "standpoint dependent," we have already acknowledged a new standpoint with regard to nature.

One way to explore a subject is to choose a theme. Another is to remain in one place, painting the same landscape, but either diminishing or expanding the scope and size of the area to be painted or the painted surface itself. In this series of paintings I narrowed the focus in each consecutive work of the same scene so that the final piece was only the focal point of all of the pieces. At the same time, I reduced the size of the image.

Regard for landscape painting has also diminished because there is so much of it, and a lot of it is inferior. Graduates of art programs, with sound backgrounds in drawing, design, composition, and painting technique, work much of the time in a studio. Even for them, so well equipped in the basics and

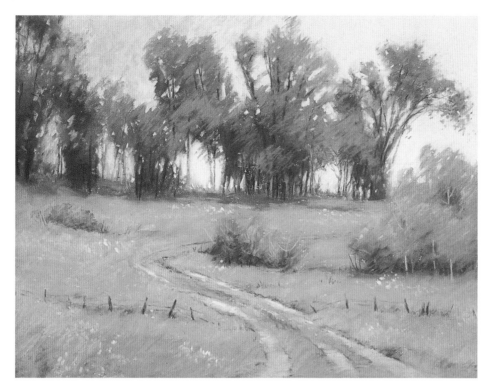

LEFT
CROSSING OVER I
9 × 12 inches, pastel, 1999

BELOW LEFT
CROSSING OVER II
7 × 9 inches, pastel, 1999

BELOW TOP
CROSSING OVER III
5 × 7 inches, pastel, 1999

BELOW BOTTOM
CROSSING OVER IV
3 × 5 inches, pastel, 1999

art history and art theory, the application of their skills to landscape painting is a challenge.

And many people today have extra time to pursue their dreams; high on that list is the idea of "becoming" an artist. While the concept is refreshing, it is also responsible for much of the "art" that finds its way before the public eye. The appeal of landscape painting to the beginner is understandable because it affords the opportunity to enjoy the camaraderie of others in a pleasant outdoor setting. Landscape painting, however, is not easy, especially when basic disciplines are absent. It is much more sensible to learn drawing, form, and composition from a contained still-life setup with a single source of light than from a subject that surrounds the artist and where the light changes constantly. The scope of landscape is overwhelming. Unfortunately validation of skill often becomes equated with the degree to which a painter can successfully "reproduce" nature on the painting surface. It is a sad commentary when the beginner is encouraged to put so much time and effort into duplicating that which cannot be duplicated. Even without all of the art classes and workshops throughout the world and the colorful appeal of how-to books, almost anyone can attain an admirable degree of proficiency in rendering work that closely resembles reality. Dedication and persistence do reap rewards and may even lead to an individual developing a style that is applauded by jurors. But copying something is not art. We must acknowledge that when landscape paintings are no more than a meticulous restatement of nature they are banal because so many, many painters rise to that level and the response, quite understandably, becomes, "So what?"

Other painters ignore the adage "paint what you know." The intricacies of nature unveil themselves to those who make the time to seek, to learn, to know, to discover, and this requires a leap of faith and patience. There are no shortcuts here. When we paint things with little understanding of what and why they are, the work that results is dead. There is no pull, no soul, no passion, and therefore usually no response. The audience for this type of work is limited to those who do not know the landscape intimately.

The poetic painter sees reality through a personal lens and that vision depends upon the richness within. "Within" is where all things unite into a cohesiveness that eliminates a need to say to the viewer, "Look here, at this, and this, and this." Once expressed, the artist's "within" becomes the poetry. Van Gogh exclaimed, "I want to paint . . . with that something of the eternal which the halo used to symbolize."

The poet-painter does not try to influence a viewer's thinking. Poetic painting is not a device used to convince, nor an argument for or against. Such tactics usually backfire because they produce work that is either saccharin or overloaded with detail. Instead, it is better to formulate a strong, clear idea, put it on the canvas with integrity and skill, and then leave it alone. It will then elicit a response that can be far more engaging than if we try to direct or control it.

It has been said of Corot that what he sought to render was "not so much Nature herself as the love he bore her." This might apply to Inness as well who wrote that the artist must always consider "how much of nature can be simplified without losing significance." It is my personal opinion that after we attain a point of reference, additional reality can be

distracting. The most masterful and evolved painters surely can look at an ordinary scene and elevate it to something else on their canvas. Most of us, however, when departing from reality on our canvas, need to physically remove ourselves from it as well. Sometimes composition takes place more easily in the studio. The use of innovative color may be easier there as well. On the other hand, the scent of lilac, the coolness of a drifting breeze, the sound of a birdsong, or the taste of salt in the air add to our feeling of well-being and connect us through our senses to the land we are painting. Many times we do our best work when we are very familiar with the landscape that attracts us, compose the idea on our canvas in the studio, return to the ambience while we work, and then finally evaluate and revise in the studio again. The creative mind is not stagnant or rigid. It is comfortable with ideas that flow freely. Focus has much to do with evaluating. Not every idea that originates while we work has to be incorporated. The focused artist does not loose sight of the concept and will sort and assimilate ideas accordingly. Some excellent ideas are simply filed for later, and the process that involves this selective sorting actually

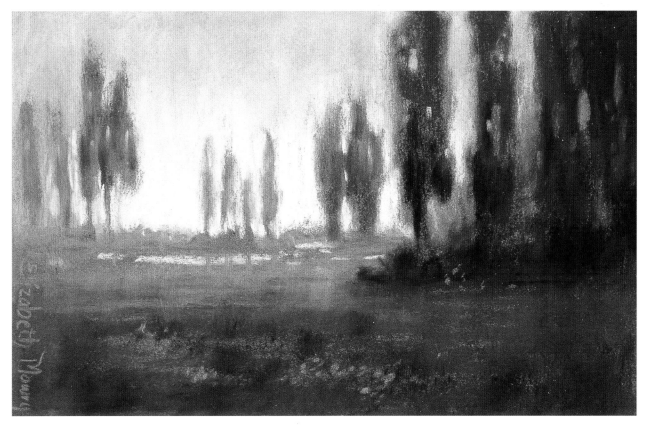

CYPRESS #6
7 × 12 inches, pastel, 1999

solidifies the work because every decision made by the artist reaffirms the initial concept. If this does not occur, then the artist knows it may be time to reevaluate the concept itself and quite possibly replace it. This happens from time to time, and it takes strength and clarity of mind to know if and when to abandon an idea in favor of another. For any artist, this can be painful and freeing at the same time. Even with the completion of a most successful painting—even when everything works, even when the artist knows and feels that it has worked, and the public responds, even then—whenever we are using nature as our subject, a sense of humility holds pride in abeyance. As Renny and Terry Russell write in *On the Loose,* "But is a picture a tenth of a thing? A hundredth?"

Nature has arranged itself quite nicely. Its diverse scale and character represent the story of evolution, from the luminous patterns in a seashell to the rocky outcrops on the highest mountains.

When humans rearrange the landscape in public parks and gardens or in the spaces surrounding their homes, they often attempt to mimic nature by putting more of what they consider beautiful into a smaller

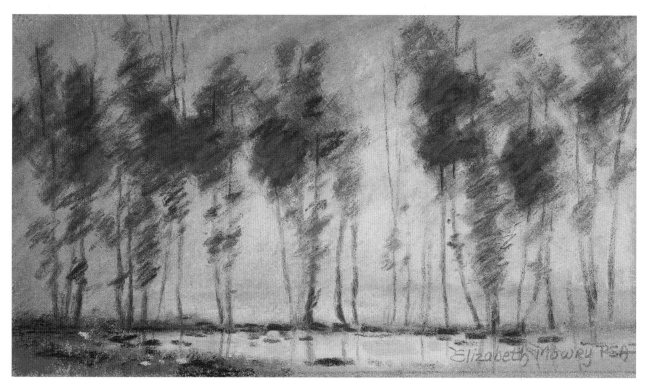

CYPRESS #12
4 × 7 inches, pastel, 1999

Another way to explore a single concept is to approach it in as many ways as possible.
Pictured here and on the previous page are two of the sixteen paintings in my cypress series.

space. In spring, a white dogwood or shad tree has an intrinsic value because of what and where it is. People see these graceful trees on wooded hillsides and want them for their own. They purchase them and arrange them or have a landscape designer do it for them. Sometimes, depending upon the designer's attunement to nature and integrity, the design works. When it doesn't, it is often a case of too much of a beautiful thing. The excess of anything is less than desirable, and, on the surface of a canvas, it is no longer beautiful. Think of a few scattered flowering white dogwood trees in a woodland space of a hundred square feet. Then visualize twenty-five of them in the same space, with other flowering trees as well. We have all seen plots designed this way. Nature seldom exudes overabundance in its design plan without the space to accommodate, and when abundance does exist in nature, the space it is given dramatizes it. Three hundred and sixty degrees of nature—as far as the eye can see on any given day—is a lot of space. When we try to put too much onto a painting surface in the name of beauty, at best we create the spectacular, but never the poetic. We tend to tidy up the landscape more than is natural and this over-groomed ambience, like a formal living room, tends to be less inviting emotionally than a natural one. In landscape, natural is most poetic.

When painting the poetry of landscape, think "strength." It is evident everywhere in nature, not only in powerful waves that blast against the rocks and winds that shape the twisted trees along a shoreline, but even in the daintiest flower. We need only to visualize a tiny seed and the odds against it before the bud finally flowers to know with certainty that survival is the ultimate display of strength. It was humanity that introduced the notion of "pretty," and the spirit of capitalism still encourages a public to collect the tasteless tributes to its mistaken superiority. Humans plant flowers in evenly spaced rows, take great pains to make paths straight, store water in aquamarine-lined pools, twist ivy into cute animal shapes, mold concrete bunnies holding concrete carrots to set in gardens, and make Hansel and Gretel houses for the birds. Nature had nothing to do with any of those things.

Among life's certainties are that time passes and ideas change. In art, one movement replaces another every decade or so. Excellence exists within all styles of painting, and the best, no matter what style, will always provide fresh insight. Yet while striving for the new and untried will always be important for many reasons, not the least of which is that creative activity implies innovative thinking, it appears that the worst of the "new" becomes overdone and "old." Years of close examination show that while "good" can be "new" all that is "new" is not always "good."

I am by no means suggesting here that the artist can purposefully set out to paint poetically and be successful at doing it. Even as we explore the "poetic" it remains so ethereal as to escape a conclusive definition. We do know this much, however: Poetic landscape is not something we can make happen. If and when it does, the artist will probably be thinking of his or her painting in terms of one "that works." All said, when a landscape painting really works, when it proclaims the deep and fundamental sanity of nature, it is frequently as pleasing a surprise to the artist as to anyone else.

THOUGHTS ON THE ARTIST AND THE POETIC LANDSCAPE

While planning a trip to Maine some time ago, I felt compelled to find and visit a place called Appledore Island because more than a decade before, on a snowy winter afternoon, I had been charmed by a personal and unassuming book by Celia Thaxter, written in the last year of her life, *Island Garden*. Like me, she was an only child, and I was struck by her sensitivity. As she stated in the book, "To a lonely child, living on the lighthouse island ten miles from the mainland, every blade of grass that sprang out of the ground, every humblest weed, was precious in my sight."

So one hundred years after the book was written, with no practical justification, I found myself obsessed with traveling to the Isles of Shoals, of which Appledore is the largest. I learned that Cornell University and the University of New Hampshire conduct classes and research at Shoals Marine Laboratory, the current occupant of Appledore, and that an island-bound boat departed weekly from Portsmouth beginning in spring until late summer when the water became dangerously rough. Serendipitously, I obtained passage on the final trip and on a crisp New England morning, I was on my way to Appledore to visit the restored garden of Celia Thaxter.

As I walked from the small boat to the site, with a volunteer who enthusiastically talked about the restoration of the garden and the marine biology courses that are now taught on the island during the summer, I remembered that the garden would not be a large one. Still, I was unprepared for what seemed such a modest little fenced-in spot of fading color, an orphan now without Celia's cottage and her family's once-so-famous resort, Appledore House, both of which had long ago burned to the ground. The grand porches that had welcomed Nathaniel Hawthorne, Harriet Beecher Stowe, John Greenleaf Whittier, Childe Hassam, and a host of others who loved being on the island each summer were gone and so was the ambience of Celia's notable warm hospitality.

The disenchantment was overwhelming. Clearly I felt nothing. What was there now did not speak to me in any way. Stunned, I hiked alone around the island, near the water's edge where a few lingering wildflowers bent gracefully in the winds along massive rock ledges and tidal pools; I sat sheltered in the cove made immortal by Childe Hassam's many paintings at the site; I tramped thoughtfully through overgrown paths and marshy wetlands of the island's rugged topography before it was time to return to the mainland. I felt disconcerted as I boarded the waiting boat. Quietly looking back toward Appledore as it became smaller and smaller, I was puzzled as to why I had failed to make a connection. I wondered why, when I was at a crossroads in my work, wavering and questioning, unsure of my direction, had I felt so strongly drawn to a little island out in the Atlantic where nothing I had hoped to find existed. Then as Appledore became only a tiny speck before it faded altogether in the glimmering expanse of sunlit ocean, I knew. I knew with a clarity beyond vocabulary.

The garden in Celia Thaxter's book was her love and her life. Her descriptive accounts of hours spent coaxing her flowers to bloom on a windswept island

of rock and coarse soil were written so lovingly that the modest garden became bigger than life, perhaps even a metaphor for it. *Island Garden* is simply the story of a woman tending a garden, nothing more, but it continues to touch the hearts of people all over the world.

With an impact like that of a brick hurled through a window, and a tearful blend of relief and happiness, I felt free. The weight of a decision had been lifted.

I would continue to paint the landscape I loved, and doing my best would of itself require challenge, and ultimately, growth. I could toss to the winds that swept Appledore my anxieties about what might be popular and center my work closer than ever upon a mindfulness based on my own life experiences. Surely only then would it be purely honest. And only honest work has the powerful capacity to touch the hearts of others.

Summary

"To walk with nature as a poet is the necessary condition of a perfect artist."

THOMAS COLE

We inhabit a world in which the technology that was designed to simplify life has complicated it. It is clear from the many titles that line shelves in bookstores that a disturbing level of anxiety has seeped into our lives. Because of our instinctive need to fix things askew, the current trend is toward searching for peace within ourselves and our surroundings. As we strive to make sense of the world we live in, we return to the landscape for reassurance, to see the clouds and the wildflowers, the rivers, and the fields. We look for paths we once walked, trees we once climbed, blackberry patches that only we knew. The familiar landscape offers a comforting sense of place. As we tend to look for meaning in our lives and in our relationships with one another, it becomes obvious that it is in our best interest to give more attention to our relationship with the landscape as well.

It has become unmistakably clear that nature has much to do with all aspects of our lives. It effects our economy, our politics, our health, and, understandably, our art. In his book *The Morally Deep World,* Lawrence Johnson writes that more and more thinkers are concluding that we need to broaden our moral horizons beyond humanity to include the nonhuman world of wilderness, objects of natural beauty, and environmental processes.

Public awareness of health and environmental issues has become a popular movement around the world. Nationally, restoration of urban and suburban natural areas, conservancy, and the establishment and stewardship of hiking trails is all part of a new social awareness that is even reflected in the stock market. And on a community level, Americans have decided that it is important to establish parks and preserve trails where they can walk in a scenic, rural setting for exercise or just to get away from traffic congestion and the hectic pace of daily life.

More and more literature centers upon the sensitive relationship between man and the landscape. Retreat centers are being founded to honor the sacredness of the earth. The idea of a mutually enhancing kinship with all life forms is replacing that of domination by humans. Father Thomas Berry, an 86-year-old monk who has emerged as a prominent spokesperson of this concept has said, "I think the poets reached deeper into the universe and have more to say to us ultimately than scientists or philosophers or people who do analysis of the universe, because they are responding to imagination . . . We associate imagination with the unreal, but in truth I think it's only through imagination and images . . . that we have some deep contact with the ultimate reality."

Environmental research and education also echo the influence of man on nature and of nature on man. Studies currently taking place in America's northwestern states show that relationships between the environment and human well-being point to the widespread use of nature on posters and murals in public buildings especially in windowless offices, stairwells, and hallways. Even this passive viewing is sought after as a means of reducing stress and enhancing the workspace. We have known for a long time that the positive effects of placing plants and flowers in our homes and offices go beyond decorative. Hospitals now have nature scenes printed on the inside of privacy curtains pulled around the beds of patients to promote rest and positive feelings. Progressive nursing homes have introduced pets and plants to enhance the lives of the inhabitants, with cheerful feedback.

Communion with nature, in its most elevated interpretation, evokes a sense of reconciliation and harmony, a mutual reverence and respect. The Indians lived in balance with nature, always careful not to destroy the land because in their wisdom they knew that if they ravaged the land, they would ultimately undo themselves. Walking Buffalo, a Stoney Indian (1871-1967), adopted by a white missionary and educated in the white man's schools, never gave up studying nature. At eighty-seven, as a representative of the Indian people, he made a world tour at the request of the American government. In England, he said, "Lots of people hardly ever feel real soil under their feet, see plants grow except in a flower pot, or get far enough beyond the street light to catch the enchantment of a night sky studded with stars. When people live far from the scenes of the Great Spirit's making, it's easy for them to forget his laws."

TOWARD THE LIGHT
18 × 47 inches, pastel, 1999

Within the last twenty-five years, and on another level, the garden has become a popular example of an intimate landscape actually planned by humans. An increasing number of people now plan their vacations to include tours of world-famous gardens such as Monet's at Giverny, the Kukendorf Gardens in Holland, the gardens at Dumbarton Oaks in Washington, D.C., and, in the area where I live, the gardens at Mohonk Preserve. These are just a few that I have visited myself. A quick survey of the vast supply of successful new garden books, tools, and accessories each year gives testimony to our return to and obsession with the landscape and a longing to work with it and leave our mark on a small part of it.

Although sensationalism and warfare still headline the front pages of our newspapers, the "Living" and "Garden" sections are thickening with growing optimism. I cannot help but wonder—if after every child has love, enough to eat, and a warm place to sleep—then if every child could have a little garden the possibility of peace throughout the world might grow by leaps and bounds.

As a youngster, I recall being embarrassed by a teacher who pointed out my misuse of the word "love" in connection with a place I described, which, as I recall, was my mother's garden. Half a century has passed and I continue to believe that it is possible to love some of the special places we experience. In his famous novel, *The Possessed,* Dostoevsky recounts the tragedy of the rootless soul, unable to lay hold of anything on earth or in heaven that gives validity to life. Psychologists such as Simone Weil are now saying that rootedness in a place is the most important and least recognized need of the human soul.

In 1993, two-time Pulitzer prize winner and humanistic psychologist E. O. Wilson coined the

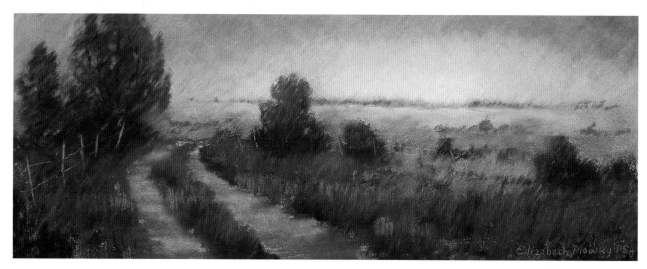

EVERGLADES PATH
8 × 19 inches, pastel, 1995

term 'biophilia' that addressed our innate affinity for all living things and, more specifically, the belief that humans have a tendency to respond positively to nature. Wilson suggested that our positive affections, for example our appreciation for lush greenery, may be genetically based on the importance such early life forms held for us. The concept captured the interest of psychologists, biologists, philosophers, and anthropologists and resulted in an extraordinary meeting of scholars to discuss and debate the issue. This ultimately led to the fifteen essays in a book on the topic called *Biophilia Hypothesis*. This book has been described as a moral compass to guide and inspire our behavior because it explores the fundamental reasons for protecting the natural world, one of which is aesthetic. In a small but significant way, the painted poetic landscape takes its place within that reasoning. "Aesthetic pleasure" literally means "pleasure associated with perception." The sense of aesthetic pleasure associated with nature is the central issue of biophilia. According to Wilson, "The aesthetic response could reflect a human intuitive recognition or reaching for the ideal in nature, its harmony and order as a model of human behavior."

Within the context of poetic landscape, the painter does not simply record nature, but instead provides insight into truth to which the observer can relate. We can easily make further associations between nature and feelings of tranquility, peace of mind, and a related sense of psychological well-being, not very different than spiritual feelings referred to as "grace." In fact, many people travel to places that have aesthetic arrangements of water, trees, rocks, or plantings seeking a spiritual experience. All this

again suggests a love of place. In *Experience of Place,* Tony Hiss convincingly points out that all people have a built-in ability to experience surroundings meaningfully in order to develop a sense of self that helps them to live more harmoniously with others. His writings provide thoughtful insights into how profoundly we can be influenced by our surroundings. If this is true, and there are many reasons to believe it is, then we would be wise to acknowledge the place for poetic landscape in our lives, in our workplace, and in public urban spaces.

Finally, although volumes have been written about poetics and the subject of landscape has been explored by many and from a multitude of perspectives, my purpose here has been merely to present a sketchy overview as a backdrop for a deeper examination of what makes a landscape poetic. Masterful poetic landscapes painted throughout the ages can be studied and enjoyed at museums and fine galleries throughout the world. Technology has made it possible for affordable prints of the most famous of them to enrich the lives of all people. The modest paintings included in this book are meaningful to me because they are based upon places that exist today. They are glimpses into the poetry I have joyfully discovered in my landscape.

There is an appointed time for everything . . .
A time to be born, and a time to die;
A time to plant, and a time to uproot the plant;
A time to weep, and a time to laugh;
A time to mourn, and a time to dance;
A time to be silent, and a time to speak.
Ecclesiastes

Bibliography

Beston, H. "The Outermost House: A Year of Life on the Great Beach of Cape Cod." In *The Norton Book of Nature Writing,* edited by Robert Finch and John Elder. New York: W. W. Norton & Company, 1990.

Borland, Hal. *A Place to Begin: The New England Experience.* San Francisco: Sierra Club Books, 1976.

Callow, Philip. *Lost Earth: A Life of Cézanne.* Chicago: Ivan R. Dee, Inc. 1995.

Carlson, John F. *Carlson's Guide to Landscape Painting.* New York: Dover Publications, 1973.

Crowe, Sylvia and Mary Mitchell. *The Pattern of Landscape.* Chichester, England: Packard Publications, 1993.

Davis, Charles E., ed. *Harvest of a Quiet Eye: The Natural World of John Burroughs.* Madison: Tamarack Press, 1976.

Duncan, David Douglas. *Sunflowers for Van Gogh.* New York: Rizzoli, 1986.

Eastman, Charles Alexander. *The Soul of the Indian, An Interpretation.* Boston: Houghton Mifflin, 1911.

Hiss, Tony. *The Experience of Place.* New York: Vintage Books, 1991.

Howat, John K. *The Hudson River and Its Painters.* New York: Penguin Books, 1978.

Johnson, Lawrence E. *A Morally Deep World: An Essay on Moral Significance and Environmental Ethics.* Cambridge: Cambridge University Press, 1993.

Kellert, Stephen R. and Edward O. Wilson, ed. *The Biophilia Hypothesis.* Washington, D.C.: Island Press, 1993.

Luscher, Max. *The Luscher Color Test.* Translated and edited by Ian A. Scott. New York: Random House, 1969.

McHarg, Ian L. *Design with Nature.* New York: John Wiley & Sons, 1995.

McLuhan, T. C. *Touch the Earth.* New York: Promontory Press, 1971.

Moore, Charles W., William J. Mitchell, and William Turnbull, Jr. *The Poetics of Gardens.* Cambridge: MIT Press, 1993.

Moore, Thomas. *Meditations: On the Monk Who Dwells in Daily Life.* New York: Collins, 1994.

Naess, Inger. *Colour Energy.* Canada: Rainbow, 1996.

Pohl, Frederick. "Growing Up in Edge City." In *EPOCH,* edited by Roger Elwood and Robert Silverberg. New York: Berkeley, 1975.

Renoir, Jean. *Renoir, My Father.* Boston: Little Brown, 1958.

Rose, Gilbert J. *Trauma & Mastery in Life and Art.* New Haven, Yale University Press, 1987.

Russell, Jerry and Renny Russell. *On the Loose.* New York: Sierra Club/Ballantine, 1969.

Sontag, Susan. *On Photography.* New York: Anchor Books, 1990.

Tinterow, Gary. "The Very Poet of Landscape." *Corot.* New York: The Metropolitan Museum of Art, 1996.

Titus, Harold H., Marilyn S. Smith, Richard T. Nolan. *Living Issues in Philosophy.* New York: Wadsworth Publishing Company, 1994.

Tucker, Paul Hayes. *Monet in the '90s: The Series Paintings.* New Haven: Yale University Press, 1992.

Werner, Alfred. *Inness Landscapes.* New York: Watson-Guptill, 1973.

Williams, Ann Bebe G. "Spiritual Pathways Through Illness." *Coping (Living with Cancer).* Jan/Feb 1997: 10–11.

Wilson, Edward O. *Biophilia.* Cambridge: Harvard University Press, 1984.

List of Plates

75. *End of Day, End of Year III.* 5 × 5 inches, pastel, 1997. Private Collection.

76–77. *Reservoir Ice.* 12 × 16 inches, pastel, 2000.

79. *Normandy Cows.* 7 × 7 inches, pastel, 1999.

81. *Mill Dam Road, Spring.* 15 × 24 inches, pastel, 1997.

82. *After the Rain.* 5 × 7 inches, pastel, 1996.

83. *Winterset Fog.* 7 × 9 inches, pastel, 1999.

85. *Remains of an Orchard.* 11 × 19 inches, pastel, 1993.

86. *Marcott Corner.* 6 × 8 inches, pastel, 1995.

87. *Scottish Road.* 5 × 8 inches, pastel, 1995.

89. *Road to the Sylvestre Farm, Normandy.* 5 × 5 inches, pastel, 1996.

90–91. *Normandy Path.* 22 × 28 inches, pastel, 1998. Private Collection.

92. *Blueberry Barrens, Maine #1.* 5 × 15 inches, pastel, 1994.

93. *Poet's Walk.* 9 × 13 inches, pastel, 1997.

95. *Along the Epte #6.* 9 × 16 inches, pastel, 1996.

96–97. *Adirondack Dusk II.* 10 × 23 inches, pastel, 1995. Private Collection.

99. *Violet Grove.* 9 × 16 inches, pastel, 1995. Collection of Frank E. Davis, Jr.

101. *Eastport Path.* 10 × 12 inches, pastel, 1994.

102–103. *Stone Ridge Orchard.* 13 × 23 inches, pastel, 1998.

104–105. *Sanibel Solitaire.* 5 × 15 inches, pastel, 1997.

106. *Giverny Road.* 8 × 12 inches, pastel, 1996.

107. *Grace.* 22 × 28 inches, pastel, 1995. Collection of Phyllis McCabe.

109. *Veronica's Lace #6.* 6 × 8 inches, pastel, 1999. Private Collection.

110. *Optimism.* 5 × 7 inches, pastel, 1994.

112–113. *End of Day.* 4 × 10 inches, pastel, 1995.

115. *Road, England.* 5 × 5 inches, pastel, 1999.

116–117. *Cypress #5.* 7 × 13 inches, pastel, 1999.

118–119. *Blueberry Barrens II.* 5 × 15 inches, pastel, 1994.

118–119. *Blueberry Barrens III.* 5 × 15 inches, pastel, 1994.

121. *Josie's Poppies.* 18 × 20 inches, pastel, 1995.

122–123. *Hudson River Aerial View #2.* 6 × 20 inches, pastel, 1994.

122–123. *Hudson River Aerial View #3.* 6 × 20 inches, pastel, 1994.

124–125. *Beach Lines.* 5 × 15 inches, pastel, 1994.

126. *Arches.* 5 × 7 inches, pastel, 1996.

127. *August River Dance.* 12 × 34 inches, pastel, 1999.

129. *Mustard Field Study.* 5 × 5 inches, pastel, 1992.

130–131. *Mont St. Michel.* 8 × 11, pastel, 1997.

132–133. *Hudson River from Kykuit.* 10 × 60 inches, pastel, 1998. Collection of John R. Williams.

132–133. *Hudson River Highlands.* 10 × 60 inches, pastel, 1998. Arts for the Parks Top 100.

134–135. *Colorado Complements.* 20 × 39 inches, pastel, 1995.

136–137. *Éntretat.* 8 × 19 inches, pastel, 1997.

138. *Queen-Anne's-Lace.* 9 × 10 inches, pastel, 1997.

139. *Daisy Heads in Snow.* 5 × 8 inches, pastel, 1993.

140. *Spruce Shadows.* 15 × 15 inches, pastel, 1992. Private Collection.

143. *Elizabeth's Water Lilies.* 18 × 20 inches, pastel, 1991. Collection of Elizabeth Smith.

144–145. *Early Moon.* 10 × 18 inches, pastel, 1997.

147. *Crossing Over I.* 9 × 12 inches, pastel, 1999.

147. *Crossing Over II.* 7 × 9 inches, pastel, 1999.

147. *Crossing Over III.* 5 × 7 inches, pastel, 1999.

147. *Crossing Over IV.* 3 × 5 inches, pastel, 1999.

149. *Cypress #6.* 7 × 12 inches, pastel, 1999.

150. *Cypress #12.* 4 × 7 inches, pastel, 1999.

153. *Shore Path, Maine I.* 6 × 9 inches, pastel, 1993.

155. *Toward the Light.* 18 × 47 inches, pastel, 1999.

156. *Everglades Path.* 8 × 19 inches, pastel, 1995.